IMAGES
of America

METEOR CRATER

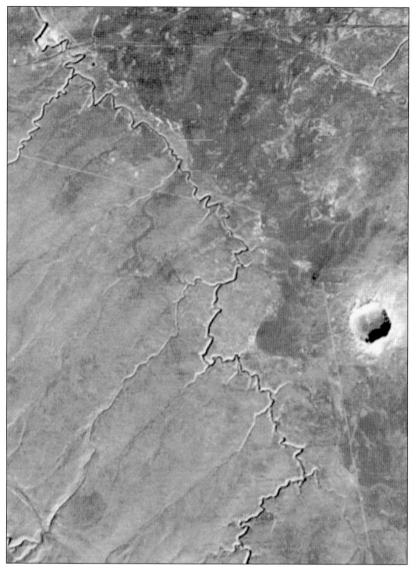

Barringer Meteorite Crater, also known as "Meteor Crater," is located 18 miles west of Winslow, Arizona. Since the 1890s, geologic studies here played a leading role in developing an understanding of impact processes on Earth, the moon, and elsewhere in the solar system. This view was acquired by the Landsat 4 satellite on December 14, 1982. It shows the crater much as a lunar crater might appear through a telescope. Morning sun illumination is from the southeast (lower right). The prominent gully meandering across the scene is known as Canyon Diablo. It drains northward toward the Little Colorado River and eventually to the Grand Canyon. Interstate 40 crosses and nearly parallels the northern edge of the scene. (Photograph by NASA/JPL Landsat 4 Satellite, courtesy of Meteor Crater Enterprises, Inc., collection.)

ON THE COVER: Dr. Dean Eppler, a geologist with NASA, is shown field-testing a suit on the crater rim in 1998. Dr. Eppler was responsible for testing several advanced spacesuits in relevant terrestrial locations around Flagstaff and Meteor Crater. Special thanks go to Dr. Dean Eppler. (Photograph by Mark Sowa, NASA photographer, courtesy of Meteor Crater Enterprises, Inc., collection.)

IMAGES
of America

METEOR CRATER

Neal F. Davis

ARCADIA
PUBLISHING

Published by Arcadia Publishing
Charleston, South Carolina

Printed in the United States of America

Library of Congress Control Number: 2016930459

For all general information, please contact Arcadia Publishing:
Telephone 843-853-2070
Fax 843-853-0044
E-mail sales@arcadiapublishing.com
For customer service and orders:
Toll-Free 1-888-313-2665

Visit us on the Internet at www.arcadiapublishing.com

*This is dedicated to three special people in my life: Cindy,
Neal Jr., and Craig. Thanks for the great ride!*

CONTENTS

ACKNOWLEDGMENTS

This story about Meteor Crater, a National Natural Landmark, and the people associated with the site could not have come to life without the assistance of many dedicated and knowledgeable people. The seed was planted for this story idea when I was in the process of writing a magazine article about the Lowell Observatory in Flagstaff, Arizona (*Route 66 Magazine*, Fall 2014). The idea was born in the Lowell Visitor Center when I came across the meteorite display entitled the Verkamp Meteorite. Growing up in Winslow, Arizona, just east of Meteor Crater, I have always had a fascination with the site and still recall visiting when I was a young boy during the 1950s. So when I saw the meteorite display at Lowell, this journey began. My first contact regarding the book idea was Suzanne Giraud-Kowalski, president of Media Impressions in Phoenix, Arizona. The company handles media and public relations for Meteor Crater Enterprises. Suzanne put me in contact with Brad Andes, president of Meteor Crater Enterprises, Inc., and Lanah Butterfield, vice president of operations. Subsequent to our initial meeting and their approval to proceed with the Images of America book, I have worked with a cast of great people, including Regents professor emeritus Carleton Moore, founding director of the Center for Meteorite Studies at Arizona State University; Drew Barringer, grandson of Daniel Moreau Barringer; Clare Schneider; Judy Chilson-Prosser, co-owner of the Bar T Bar Ranch Company; Kevin Schindler, outreach director at Lowell Observatory; Stephen Verkamp; Herb Hilkins and family; Patricia L. Walker, archivist at the Museum of Northern Arizona; Dr. David Kring, senior staff scientist and the principal investigator (and founder) of the Center for Lunar Science and Exploration; Dr. Carolyn Porco, director of the Cassini Imaging Team; Dr. Paul Sipiera with the Planetary Studies Foundation; and David Portree with the US Geological Survey (USGS), Flagstaff; my thanks also go to the Jet Propulsion Laboratory (JPL) and NASA. Without the assistance, expertise, and precious time provided by all of these people and others, this book could not have come to life. If I have missed anyone, my humble apologies, and I extend my sincerest gratitude and thanks to each and every one. Finally, I want to thank my sister, Anita Davis Henling, for her support and encouragement, and last but not least, my wife, Cindy Davis, for her undying support, patience, and assistance during this project. The assignment required extensive time spent secluded and travel away from the homestead. Thank you, everyone!

INTRODUCTION

The site has taken on several different names since its discovery, including Diablo Canyon Crater, Coon Mountain, and Barringer Meteorite Crater; today, it is simply referred to as Meteor Crater. Found on a continuous plain extending for miles in the high desert plateau of the southwestern part of the United States, it is the best preserved impact crater in the world. Approximately 50,000 years ago, out of the northeastern sky, a pinpoint of light grew rapidly into a brilliant fireball. This body had probably broken off an asteroid during an ancient collision in the main asteroid belt (between Mars and Jupiter) some half billion years ago. Hurtling about 26,000 miles per hour, it was on a collision course with Earth. In seconds, it passed through the earth's atmosphere with little loss of velocity or mass. In a blinding flash, a huge iron-nickel meteorite or dense cluster of meteorites, estimated to have been about 150 feet across and weighing several hundred thousand tons, struck the rocky plain with an explosive force greater than 20 million tons of TNT, 150 times the power of the Hiroshima atomic bomb. Traveling at supersonic speed, this impact generated immensely powerful shock waves in the meteorite, the rock, and the surrounding atmosphere. In the air, shock waves swept across the level plain, devastating all in the meteor's path for a radius of several miles. In the ground, as the meteorite penetrated the rocky plain, pressures rose to over 20 million pounds per square inch, and both iron and rock experienced limited vaporization and extensive melting. Beyond the affected region, an enormous volume of rock underwent complete fragmentation and ejection.

Initially, most scientists rejected the possibility of an impact crater, believing that all natural landforms had been created slowly over thousands or even millions of years rather than in a single cataclysmic moment. These included the highly respected and well-known Grove Karl Gilbert, chief geologist for the USGS. He became interested in the Arizona Meteor Crater in 1891. In supporting his methodical approach to science, he visited the crater to test two hypotheses. The first was that the crater was, in fact, formed by the impact of a giant meteorite. The second focused on a possible explosion of superheated steam caused by volcanic activity. The results of both tests were negative, so Gilbert concluded a steam explosion caused the formation and the thousands of meteorite fragments lying around the area were simply coincidental.

Along came Daniel Moreau Barringer. A Philadelphia mining engineer and attorney known for his tenacity and impatience, Barringer became aware of the existence of the crater and the meteoritic iron around it in 1902. Enlisting the help of his friend Samuel J. Holsinger, Barringer set out to prove the impact crater theory. A few months later, Holsinger confirmed, by letter, that small balls of meteoritic iron were randomly mixed with the ejected rocks around the Meteor Crater rim. The random mixture of rock and iron convinced Barringer the crater had been created simultaneously with the arrival of the meteorites. In 1908, Barringer's conclusions were championed by the eminent geologist George P. Merrill. Merrill analyzed two new varieties of sandstone discovered at the crater by Barringer and concluded both must have been produced by a brief but enormous pressure, greater than any known to occur through terrestrial processes. There were other facts pointing to Barringer's hypothesis as well.

Due to Barringer's outside status in the scientific world and his forceful personality, his theories were not readily accepted by other prominent scientists. While this debate continued, Barringer, along with other investors, set up a mining venture called Standard Iron Company at the crater. He was convinced there was a mother lode to be found. However, early drilling efforts encountered quicksand beneath the crater floor. So they set up rigs on the south rim at a great expense, again coming up empty. Further investment and drilling found nothing at the site, and by late 1929, it became clear the meteorite had vaporized on impact. By November 30, 1929, Barringer was dead of a massive heart attack, having lost nearly all of his fortune along with hundreds of thousands of dollars entrusted to him by his investors.

While he lost a fortune in trying to mine the mother lode, his real legacy is having provided the initial evidence of the crater's true origin. Daniel Barringer's pioneering work provided the initial and crucial clues to the crater's origin, and the scientific community gave the crater its formal scientific name—Barringer Meteorite Crater—some 30 years after his death. In addition, a crater on the far side of the moon is named for him. For over 70 years, the Barringer Crater Company has provided funding in support of research and education in the field of impact cratering around the world as well as support for master's, doctoral, and postdoctoral students interested in the field of meteoritics.

Through the years, proving this was an impact crater continued and became a major and controversial story. Total acceptance that the crater was caused by an extraterrestrial object was not fully recognized in the scientific world until halfway through the 20th century. In 1963, Eugene "Gene" Shoemaker, a prominent geologist and one of the founders of the field of planetary science, published the landmark paper analyzing the similarities between the Barringer crater and craters created by nuclear test explosions in Nevada. Carefully mapping the layers of underlying rock and the layers of ejected rock, he demonstrated that the nuclear craters and the Barringer crater were structurally similar in nearly all respects. His paper provided the clinching arguments in favor of an impact, finally convincing the last doubters. Continuing research at the Barringer Meteorite Crater and other impact sites has taught us not only about our own world but also about the history of the solar system out of which it was born. In the words of Gene Shoemaker, "the impact of solid bodies is the most fundamental of all processes that have taken place on the terrestrial planets. Collision of smaller objects is the process by which the terrestrial planets were born."

In the late 1930s and early 1940s, the Bar T Bar Ranch, owned by the Tremaine and Chilson families, surrounded Meteor Crater, which was owned by the Barringer family. Bar T Bar contacted the Barringers and requested grazing rights for the land around the crater. The family agreed. At the same time, Bar T Bar also requested rights to the tourist business, and the Barringers agreed to this arrangement as well. With these agreements in place, the two parties entered into a long-term lease. The company opened the visitor center in the one-room museum in January 1942. Originally, the parties were scheduled to sign the lease on December 7, 1941, but the Japanese attack on Pearl Harbor moved the schedule back and the lease was signed the next day.

With the crater under Bar T Bar Ranch administration, Ernest Chilson's mother, Emma J. Chilson, became the first company employee at the visitor center. Visitors were few back then, as most would not drive the six miles of rough and rock-strewn road south from Route 66 to the museum. Business picked up in 1955, when the road was finally paved. In 1959, the lease was renegotiated for 199 years between the company and the Barringer family, and that lease is active through 2158. In 1979, George Shoemaker was hired to manage the Meteor Crater business; the company began to see site improvements and an increase in visitors, and the steady growth has continued through the years. In 1990, all the ranching operations were sold in total to the Chilson-Prosser family. Meteor Crater Enterprises, Inc., continues to be privately owned by the Tremaine and Prosser families and has been operating successfully for over 70 years with no assistance or support from the government.

Today, it is estimated there are approximately 160 meteorite impact craters worldwide, both exposed and unexposed, but the Barringer Meteorite Crater stands out from the others in preservation and scientific research. Located in the northeastern Arizona high desert approximately

18 miles west of Winslow, this sizable hole in the ground, which is nearly one mile across, 2.4 miles in circumference, and more than 550 feet deep, is right in our own backyard. It is a short six-mile drive south of Interstate 40. Take exit 233 to the site and discover why it is known as one of the best-preserved and most-visited impact craters on Earth. There have been numerous books and periodicals written about Meteor Crater, the meteorites, and the crater's scientific value, but this book, with supporting images, is more about the people, from the early scientists to the many visitors, from famous astronauts who have walked on the moon to elementary school students on class field trips from neighboring Winslow. The story covers some history of the crater's founding and the many people who have been and presently are associated with the custody and maintenance of the site, preserving it for future science study and generations of visitors. These people include geologists, astrophysicists, astronauts, and generations of families named Barringer, Tremaine, and Chilson-Prosser. All have influenced and shaped what the site has become, each adding his or her signature to the famous landmark. Today, these families, supported by Brad Andes, president, and Lanah Butterfield, vice president of operations, along with a handful of dedicated people, continue the legacy of sharing the history and science with 250,000 visitors each year from around the globe while they continue to focus on preserving the scientific integrity of the crater for future generations.

One

THE EARLY SCIENTISTS, BARRINGER, AND CONTROVERSY

In 1891, mineralogist Albert E. Foote presented the first scientific paper about the meteorites of Northern Arizona. So started the speculation and investigations of what today is Barringer Meteorite Crater. Since that humble beginning, the search for answers has included several key players, with the most prominent being G.K. Gilbert, followed by Daniel Barringer. Barringer was the first to proclaim the crater was caused by an extraterrestrial impact, but this hypothesis was not readily accepted in the scientific world. This controversy would last for almost a century, until 1960, when Eugene Shoemaker, an American geologist and one of the founders of the field of planetary science, discovered a new mineral at the crater. The mineral, a form of silica, was called coesite. The mineral's formation requires extremely high pressures and temperatures, greater than any occurring naturally on earth. Finally, in 1963, Shoemaker published his landmark paper analyzing the similarities between Barringer Crater and craters created by nuclear explosions in Nevada. His paper provided the clinching arguments in favor of an impact crater, finally convincing the last doubters. Shoemaker is best known for codiscovering the comet Shoemaker–Levy 9 with his wife, Carolyn S. Shoemaker, and David H. Levy in 1993. Scientists continue to visit and study the best-preserved crater on Earth. Some of the best-known geologists helped train the Apollo astronauts in the 1960s and early 1970s. Studies and work by NASA have continued in supporting possible missions to Mars planned for sometime in the 2030s. The progress of science is seldom simple. Neither Gilbert nor Barringer understood the crater, because they did not take into account the enormous speed and release of energy from the meteorite impact. Various studies and discoveries by different scientists over six decades would be necessary before the impact theory emerged as the unchallenged winner.

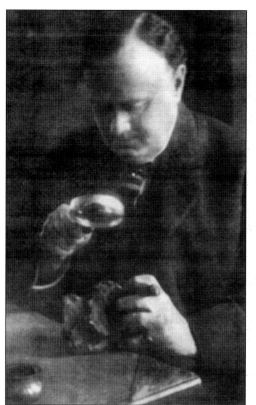

This is an early photograph of Daniel M. Barringer studying a meteorite with a magnifying glass. His legacy—hypothesizing and proving that Meteor Crater is an impact crater—was not recognized for many years by the scientific community. His early work established the basis for what would become a major field of science, the study of impact phenomena throughout the solar system. (Courtesy of Meteor Crater Enterprises, Inc., collection.)

Daniel Barringer is shown below on horseback scouting the outside rim of Meteor Crater for possible meteorite fragments or perhaps looking for possible drilling sites. When he originally heard about the crater from friend and confidant Daniel Holsinger, he decided to prove its extraterrestrial origin and in the process make a fortune mining and selling the nickel and iron from outer space. (Courtesy of the Barringer family collection.)

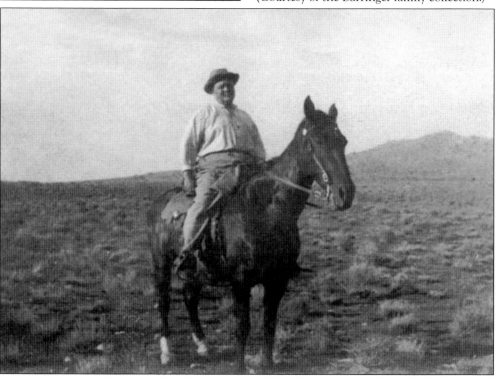

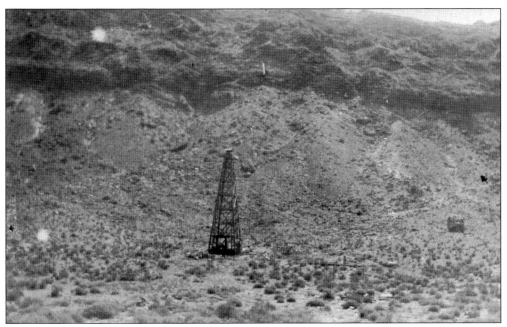

This lone drilling tower is located on the floor of the crater. Ultimately, all the exploration and drilling was unsuccessful, but at one point, Daniel Barringer was arguing that the worth of the iron and nickel ore could exceed $100 million dollars, around one billion in today's dollars. (Courtesy of the Barringer family collection.)

Two men are operating a wench and either lowering or raising a third man, shown in the center of the shaft opening. This photograph was taken at the bottom of the Meteor Crater floor. Notice the sizable building behind the man on the left. (Courtesy of the Barringer family collection.)

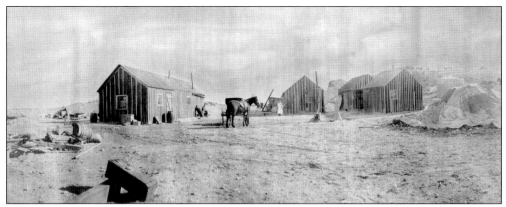

An early image shows a working camp established by Barringer at Meteor Crater. Barringer's quest to find and mine the meteorites was based on a simple hypothesis: "If you are looking for an object that created the hole, it makes sense to start looking somewhere beneath the center of the hole." By mid-1908, twenty-eight holes had been drilled in the crater floor, but there was no evidence of a large meteoritic mass to be found. (Courtesy of the Barringer family collection.)

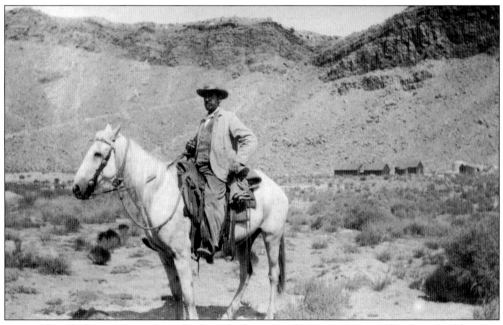

An unidentified man sits on horseback at the bottom of Meteor Crater. The three buildings in the background are unidentified. (Courtesy of the Barringer family collection.)

This bust of Daniel Barringer features an inscription finally giving overdue recognition that he was the first to prove Meteor Crater was created by impact. Acceptance among the scientific community was not without controversy. Daniel's fascination, persistence, and ultimate obsession followed him from the first visit to the site in 1903 until his untimely death in 1929. (Courtesy of Meteor Crater Enterprises, Inc., collection.)

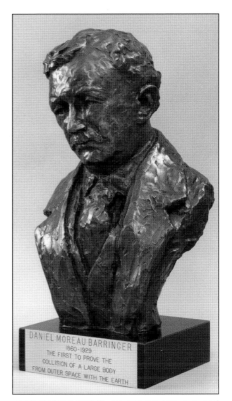

DANIEL MOREAU BARRINGER
1860-1929
THE FIRST TO PROVE THE
COLLISION OF A LARGE BODY
FROM OUTER SPACE WITH THE EARTH

This is an image of the Barringer Lunar Crater, named for Daniel Barringer (1860–1929). The crater is located on the far side of the moon in the southern hemisphere. The name was adopted by the IAU (International Astronomical Union) in 1970. (Courtesy of Dr. David Kring.)

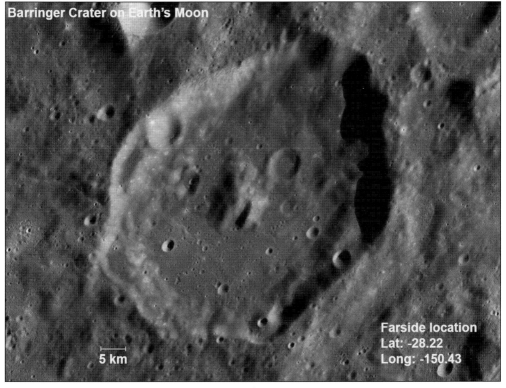

Barringer Crater on Earth's Moon

5 km

Farside location
Lat: -28.22
Long: -150.43

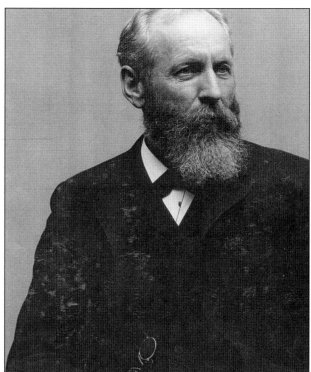

Grove Karl Gilbert, the prominent geologist, visited Meteor Crater in 1891 to determine its origin. In keeping with his methodical approach to science, Gilbert visited the crater to test two hypotheses about its formation. The first was that it had been formed by the impact of a giant meteorite. The second was that it was the result of an explosion of superheated steam, caused by volcanic activity far below the surface. The results of both tests were negative. Gilbert concluded that the crater was created by a steam explosion and that thousands of meteorite fragments lying around it were simply a coincidence. (Courtesy of Meteor Crater Enterprises, Inc., collection.)

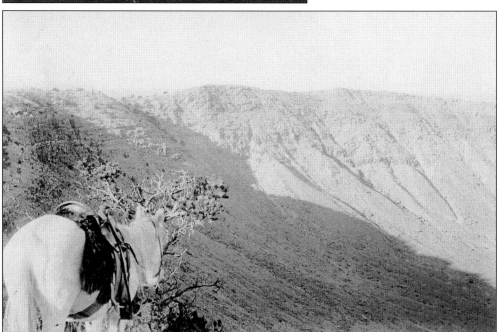

This view is looking inside the Meteor Crater bowl in 1891. Grove Karl Gilbert, who first interpreted the moon's craters as impacts, studied Coon Butte (Meteor Crater) and, in the end, decided it was most likely a maar (a low-relief volcanic crater). In 1902, Daniel M. Barringer, a New Jersey steel magnate, investigated the site as a possible source of iron and became convinced that it was a meteorite impact crater. (Courtesy of Meteor Crater Enterprises, Inc., collection.)

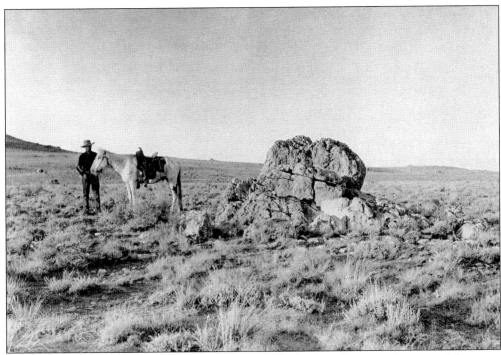

These early photographs show unidentified individuals checking for meteorites around the crater rim. The above image is of a man next to a limestone block ejected from Coon Butte/Meteor Crater. Below, a man is shown on the outside of the crater rim in the background. (Both, courtesy of Meteor Crater Enterprises, Inc., collection.)

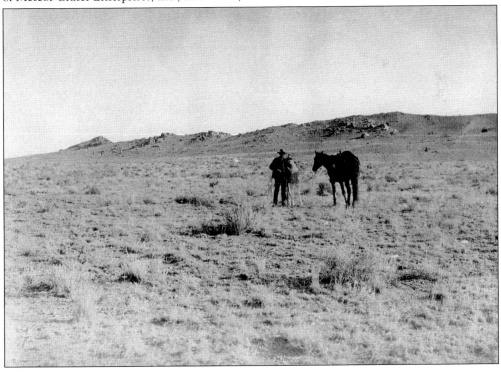

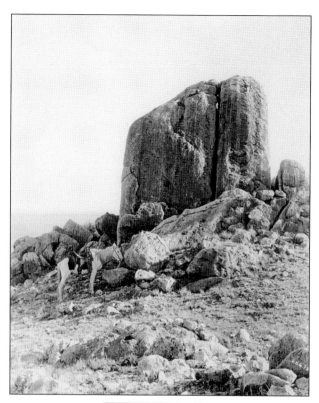

At left is an early image of a limestone mound on the eastern rim, photographed in 1891. Meteor Crater was first described by European settlers in 1871 and named Franklin's Hole. Later settlers in the area renamed it Coon Butte. Below is the same outcropping today with the author in the lower left. In geologic terms, 124 years is a short period, and time has done little to change the rock-strewn terrain. (Left, courtesy of Meteor Crater Enterprises, Inc., collection; below, photograph by Cindy Davis, author's collection.)

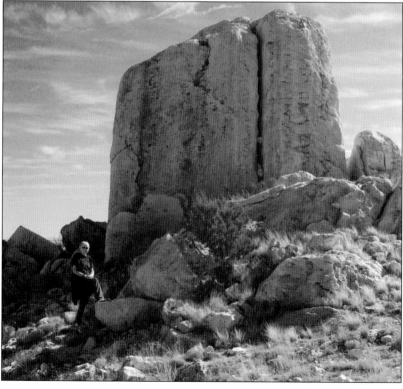

Two

THE BAR T BAR
CONNECTION

Meteor Crater has been a family affair for generations, starting with the Daniel Barringer family and later the Tremaine and Chilson families. Burton Gad "Lucky B.G." Tremaine and Napoleon Warren "Boss" Chilson met by chance in 1930. The two men came from diverse backgrounds. Lucky B.G. was a successful Ohio businessman, while Boss was a lifelong rancher and landowner in Arizona. From that initial meeting, Tremaine and Chilson established a partnership that brought their families together in a friendly relationship that has endured through four generations. When B.G. acquired the original Bar T Bar Ranch, he hired Boss to manage the business and, as the saying goes, the rest is history. Over time, the Tremaine and Chilson families' partnership has extended into other ventures. When they acquired the 100,000-acre Pitchfork Ranch from the Babbitt family in 1939, they took little notice of the gaping hole in the property and the two-square-mile parcel surrounding Meteor Crater that Daniel Barringer had patented decades prior. Certainly, neither partner envisioned getting into the tourism business. The site was reached via a dirt road from Route 66 to the one-room museum on the crater rim that housed only a few meteorites and little explanation of the natural wonder. How times change! Today, the family ties remain as strong as ever, with focus on the business and future growth. This is clearly supported by the addition of the modern admissions offices completed in 2013, phase one of a 10-year master plan that includes further expansion of the museum and surrounding facilities. The Bar T Bar Ranch is owned by Boss Chilson's granddaughter, Judy Chilson Prosser, and her husband, Bob Prosser. Considering all of the company acquisitions, mergers, and break-ups of the past few decades, the persistence of the friendship between the families is amazing. Twice a year, the Tremaines and Prossers, along with the Meteor Crater Enterprises management, continue the tradition of attending board meetings to discuss the crater operation, proposed changes, and plans for continued improvements to attract future generations through the 21st century and beyond.

A c. 1935 photograph shows Boss Chilson (left), Warren Tremaine (center), and Kit Tremaine sitting on a fence at the Bar T Bar Ranch. The ranch was located on the Mogollon Rim in Apache County. Tremaine family members often visited the ranch sites during the summer months to ride and relax. The visits were often coordinated with the annual Meteor Crater Enterprises, Inc., board meetings. (Courtesy of the Judy Chilson Prosser collection.)

THE TREMAINE ALFALFA RANCH AND MILLING COMPANY

BY AMENDMENT TO ITS ARTICLES OF INCORPORATION,

SHALL HEREAFTER BE KNOWN AS

BAR T BAR RANCH, INC.

BEGINNING JUNE 1, 1950, ALL BUSINESS WILL BE
CONDUCTED UNDER THE NEW NAME.

EVELYN CHILSON
Secretary

ERNEST W. CHILSON
Vice-President

This is the notification announcing that Tremaine's Alfalfa Ranch & Milling Company was formally changing its name to the Bar T Bar Ranch, Inc., on June 1, 1950. The ranch's progressive management practices over the years earned the respect and loyalty of its working cowboys, and many remained in the employment of the Bar T Bar for two decades or longer. (Courtesy of the Judy Chilson Prosser collection.)

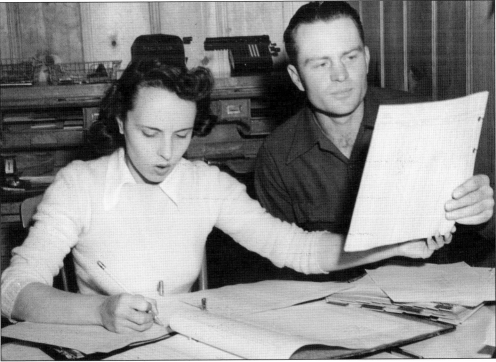

Ernest and Evelyn Chilson are pictured in their office around 1955. The Meteor Crater office was housed at the ranch headquarters, because Evelyn did the bookkeeping and prepared financial statements. Evelyn assumed responsibility for keeping ranch records, and she was one of the original incorporating officers of Meteor Crater Enterprises, Inc. She severed in that capacity from 1941 to 1977. When Evelyn retired, offices for both Meteor Crater and Bar T Bar were moved outside of the Chilson home. (Courtesy of the Judy Chilson Prosser collection.)

Ernest W. Chilson (left), president of Meteor Crater, and George Foster stand on the rim of Meteor Crater. George and his wife arrived at the site in 1947. In 1954, he was hired as the site manager, and he worked in this capacity until retirement in 1967. Chilson and Foster worked together closely during the years Foster managed the museum. (Courtesy of the Judy Chilson Prosser collection.)

Two unidentified women are shown with Ernest Chilson, on the right, relaxing at Meteor Crater. Known as "Boss," Chilson was a cowboy from his childhood, and whenever the opportunity presented itself, he and his brothers invested in ranch properties and cattle permits. (Courtesy of the Judy Chilson Prosser collection.)

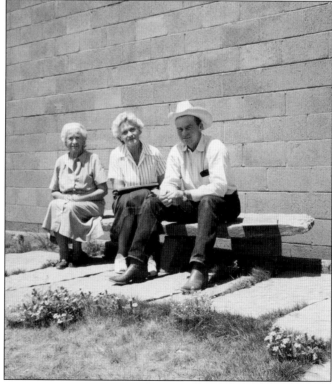

Judy Chilson (left) and her father, Ernest are at the summer ranch, then located at Hay Lake on the Mogollon Rim. At the age of 22, Judy was elected to the board of directors of Meteor Crater Enterprises, Inc. Today, she and her husband, Bob Prosser, own and operate the Bar T Bar Ranch. Judy remains an active board member of Meteor Crater. (Courtesy of the Judy Chilson Prosser collection.)

This is a c. 1968 photograph of one of the many Meteor Crater Enterprises, Inc., board of directors meetings that were conducted at the Bar T Bar Ranch house. All of the principal family members—the Tremaines and Prosser-Chilsons—continue to manage the board meetings at least twice annually. One meeting is attended via electronic hook-up, and the second is attended in person at a selected site, usually in the western part of the United States. (Courtesy of the Judy Chilson Prosser collection.)

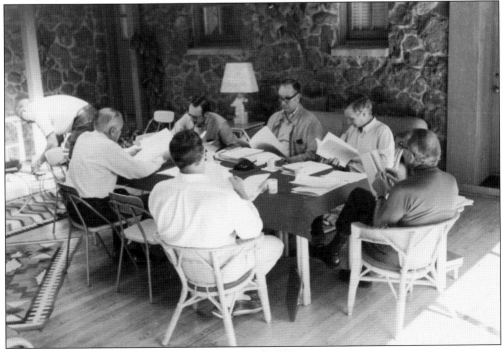

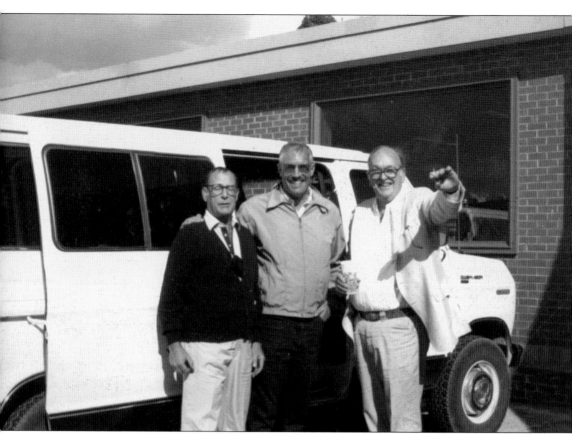

Three of the Meteor Crater Enterprises, Inc., board members take time out from a board meeting to visit the Meteor Crater museum. Shown here are, from left to right, Burton G. Tremaine Jr., H. Alan Tremaine, and Warwick J. Hayes. (Courtesy of Gene and Betty Collier collection.)

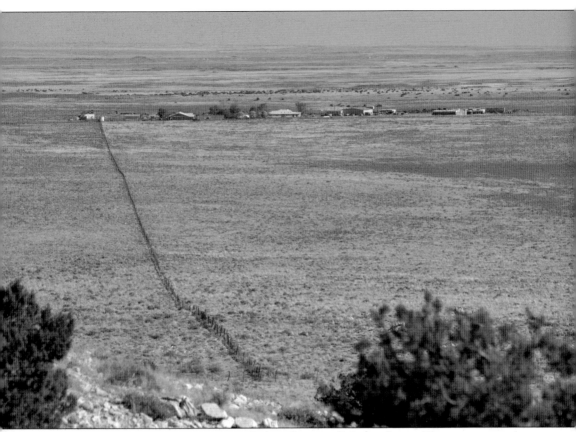

Shown here is the Bar T Bar winter ranch directly east of Meteor Crater. The image was taken from the top of the eastern rim trail. The main ranch house is located in the center of the buildings that make up the ranch. This property is the Bar T Bar primary headquarters, located in the high desert adjacent to the Meteor Crater. The rest of the winter range is bounded by the Hopi Three Canyon Ranches and a buffalo ranch maintained by the Arizona Game and Fish Department. Average annual precipitation here ranges from six to seven inches. (Author's collection.)

This is the Bar T Bar branding iron. The Bar T Bar brand was first purchased from John Anderson in 1941 by H. Alan Tremaine to be used on the Bar T Bar Ranch, near Rye, Arizona. For specific identifications, the calves were branded each spring, steers on their left side and heifers on their right side. (Courtesy of the Judy Chilson Prosser collection.)

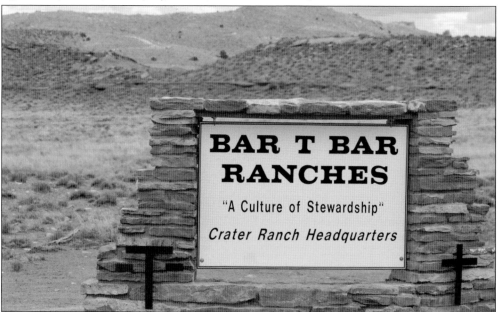

The present-day Bar T Bar Ranch sign is located on the east side of Meteor Crater Road at the junction of ranch road. The winter ranch house is just three miles east of this turnoff. In the view looking south in this photograph, the apparent mesa on the horizon is the northwest rim of Meteor Crater. The small structure barely visible to the left-center, on the crater rim, is the remnants of the original museum, built in 1912. (Author's collection.)

This perspective is looking west after leaving the Bar T Bar winter ranch road and driving back to Meteor Crater Road. The crater rim is discernible in the left-center of the photograph. The photograph was taken about a half mile east of the Bar T Bar. Interstate 40 parallels the ranch road approximately five miles to the north. (Author's collection.)

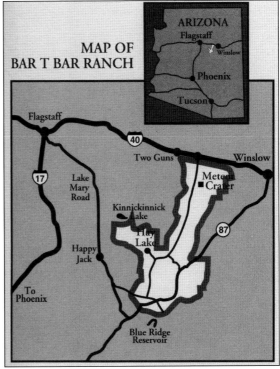

This illustrative map shows the ranch property stretching from the Blue Ridge Reservoir on the Mogollon Rim on the north to just south of Interstate 40. The summer ranch is located at Hay Lake, while the winter ranch is just south of Interstate 40 and a few miles east of Meteor Crater. Bar T Bar is a year-round working cattle ranch covering a total of 297,064 acres. (Courtesy of the Judy Chilson Prosser collection.)

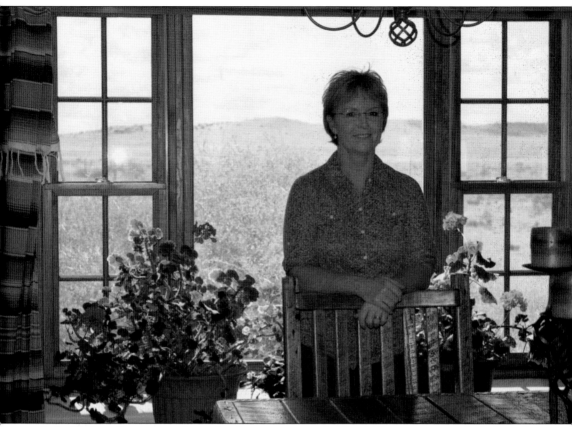

Judy Chilson Prosser stands in the dining room at the Bar T Bar winter ranch. Judy is the granddaughter of Boss Chilson, and she and her husband, Bob, now own and operate the Bar T Bar Ranch. Twice a year, along with their staff of cowhands, they drive approximately 1,500 head of cattle between the two properties. The eastern rim of Meteor Crater, on the horizon, is approximately three miles from the ranch house. (Author's collection.)

Three

EARLY STEWARDS OF THE CRATER

The Goeglein family arrived at Meteor Crater in 1927. The family members were Walter Goeglein, a mining engineer; his wife, Dora; their daughters Doris, Barbara "Bobbi," and Lorraine; and their son Ralph. The family moved to the crater area when Walter accepted a job managing the drilling shaft on the south rim of the site. During this time, the family acquired the first known concession—a 10-year lease—with the Meteor Crater owners, the Barringer family. Their living quarters were located on the south rim, along with other buildings that housed the drilling crews. The contract with the Barringer family allowed them to manage the original one-room museum on the northwest crater rim. They were drilling for the meteorite and did, in fact, hit what was said to be a large meteor piece about 780 feet below the surface. The object broke the bit, and with no additional money to purchase a new one, the operation was shut down. Life was far from glamorous at that time, and the onset of the Depression only worsened conditions. The family began to hunt antelope, rabbits, and deer to keep food on the table. While the family could not find buyers for the meteorites, when they went to Winslow to shop, they could sometimes find stores that would trade goods for a meteorite. However, they continued their efforts in searching for more meteorites and it finally paid off. While they could not locate a market in the United States, they eventually sold some to German universities interested in the extraterrestrial rocks. Walter became creative and made laundry soap using the lechatelierite powder left by the meteorite impact. He called the product Stardust Laundry Soap and sold it through stores in Winslow. Managing the museum was basic and consisted of Walter bringing people in and, for 25¢, explaining the crater origins using a site schematic prepared by Daniel Barringer. Walter would then take the visitors to the rim's edge. When the Goeglein family left Meteor Crater in early 1940, they moved to Flagstaff, Arizona, and were employed at the Navajo Ammunition Depot in Bellemont, 10 miles west of Flagstaff. Outside of the family, not many people know or have recorded much about the Goegleins' years working and living at the crater. The family story and photographs were shared by Herb Hilkins Jr., grandson of Walter and Dora Goeglein and son of Lorraine and Herb Hilkins Sr.

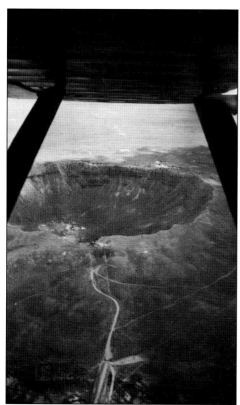

This early aerial view looks southward at Meteor Crater. The dirt road in the center of the photograph is Meteor Crater Road, leading up to the original museum site on the crater rim. The road to the right of the main road leads around the lower west side of the rim to one of the drilling sites, living quarters, and other supporting buildings on the south rim where the Goegleins and other workers lived while at the crater. (Courtesy of the Herb Hilkins family collection.)

Pictured in front of the original museum building are, from left to right, Doris, Walter C., and Dora Goeglein. They are the grandfather, grandmother, and aunt of Herb Hilkins. The museum was constructed in 1912, and the Goeglein family arrived in 1927. It is not known if anyone prior to the Goegleins managed a concession at the museum. The Goeglein family managed the museum and concessions from 1927 to 1940. (Courtesy of Meteor Crater Enterprises, Inc.)

These two illustrations are from the logbooks maintained by Walter Goeglein. Above is the log entry listing drillers' daily work hours by date. In May 1932, the pay rate was $3 per day. The log entry below, dated April 14, 1933, lists the museum sales, titled "Tourist Trade." The ledger includes separate columns listing the sales of meteorites and postcards at the museum. (Both, courtesy of the Herb Hilkins family collection.)

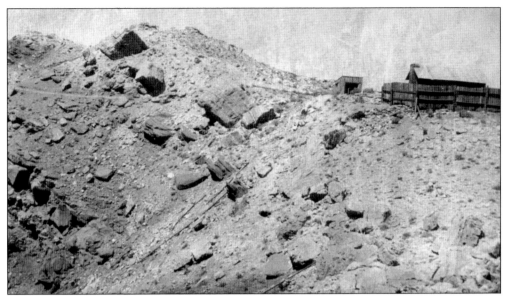

This is an early photograph of the original one-room museum on the northwest side of crater rim. This picture appears to have been taken from just below or from the top of the rim looking west-northwest. Notice how close the structure is to the inner wall of the rim. To the left is an outbuilding that could have been used for food or equipment storage. (Courtesy of the Herb Hilkins family collection.)

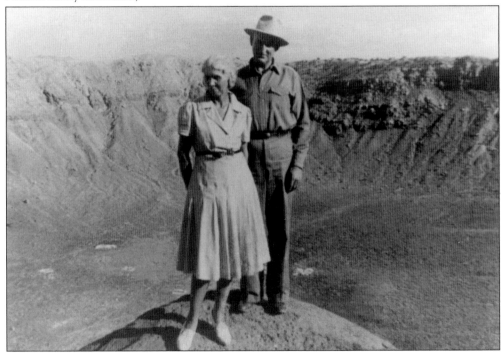

Walter and Dora Goeglein take a rare break on the crater rim. With their daily duties at the museum and Walter's responsibilities managing the drilling rigs and crews, it was not often that the family enjoyed any downtime to relax and enjoy the site. (Courtesy of the Herb Hilkins family collection.)

According to Herb Hilkins, the above photograph shows the remains of the building where Lorraine and Doris Goeglein lived on the south rim. This was also the quarters for the pet coyote. He would come in the house in the early evening and spend the night with the ladies, comfortably joining them on the bed. Below, the author is shown to the left of a similar structure still standing today. (Above, courtesy of the Herb Hilkins family collection; below, photograph by Cindy Davis, author's collection.)

Walter and Dora Goeglein stand behind their car. Directly behind the automobile is the original one-room museum and visitor center on the northwest crater rim. A 1940 Arizona license plate is on the automobile. This would be the last year the Goegleins lived and worked at the Meteor Crater site. A new lease was offered, but due to some differences between the parties, the Goegleins declined the offer and decided instead to move to Flagstaff. (Courtesy of the Herb Hilkins family collection.)

Walter Goeglein (left) and his son, Ralph, stand behind their car at the south rim of Meteor Crater. Since Walter is dressed in slacks, sport coat, and tie, it appears they were getting ready for or returning from church or perhaps some type of social event. The building in the background is thought to be one of the living quarters used for the drillers, families, and supporting work crews. (Courtesy of the Herb Hilkins family collection.)

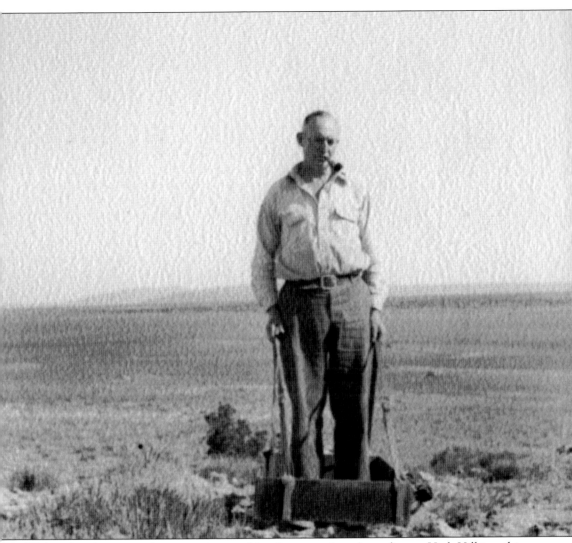

Walter Goeglein is on the crater rim searching for meteorites. According to Herb Hilkins, this particular device was a metal detector made by Walter. When metal was detected, the device would make a humming sound. It was later manufactured by multiple companies and called a radioscope. The device was equipped with batteries connected to wires around the base structure, and when activated, it detected minerals below the surface. Because they are made up of mostly iron and nickel, metal-bearing meteorites attracted the magnet. (Courtesy of the Herb Hilkins family collection.)

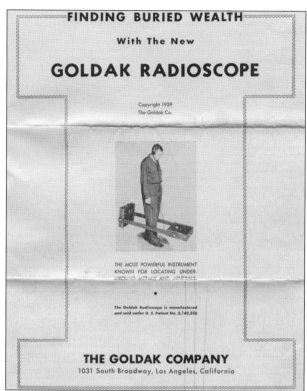

This is the cover for a 1939 owner's manual for the Goldak Company radioscope. The company advertised the equipment as state of the art and made from tough materials for rugged service. The company also offered a money-back guarantee on this model on the basis that it would outperform any other metal detection device. According to Herb Hilkins, the homemade metal detector used by Walter was the forebear to the manufactured devices. (Courtesy of the Herb Hilkins family collection.)

Walter Goeglein is shown here with his horse somewhere around the Meteor Crater rim. Walter would frequently use the horse to ride around the outside crater rim and beyond in search of meteorites. Due to gasoline shortages, Walter and his family also used the horses to ride into Winslow, 18 miles to the east of the crater, to pick up supplies and groceries. (Courtesy the Herb Hilkins family collection.)

These are the Goeglein sisters on the Meteor Crater rim. Above is Doris Goeglein, Herb Hilkins's aunt. The building in the background appears to be living quarters. Below is her sister and the mother of Herb Hilkins, Lorraine Goeglein. The sisters look enough alike they could almost pass for twins. The two young women spent an adventuresome 13 years with the family working and exploring the region around the Meteor Crater site. (Both, courtesy of the Herb Hilkins family collection.)

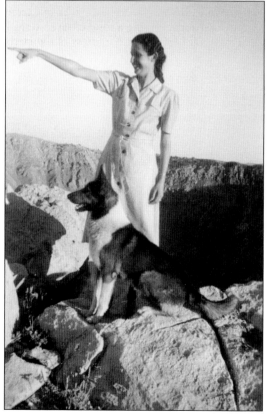

The Goeglein family is shown with a little downtime on the crater rim. Above, Ralph and Lorraine spend a few moments relaxing with their pet collie. At left, Lorraine is pointing out something of interest on the rim. Life during the 1930s, in the middle of the Depression, was very basic for many working and living at and around the site. (Both, courtesy of the Herb Hilkins family collection.)

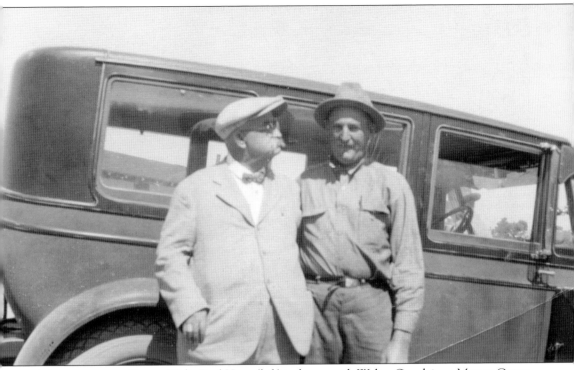

Arizona governor George Wylie Paul Hunt (left) is shown with Walter Goeglein at Meteor Crater in October 1928. W.P. Hunt was the first governor of Arizona, serving a total of seven terms. Hunt also served in both houses of the Arizona Territorial Legislature. (Courtesy of the Herb Hilkins family collection.)

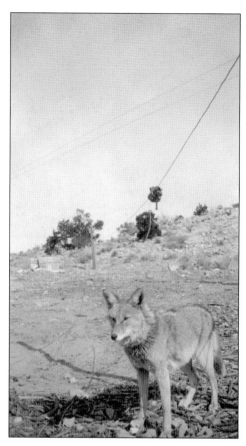

This is the pet coyote the Goegleins found abandoned around Meteor Crater when the animal was just a baby. The coyote became domesticated and lived with the family for a long period of time. At left, the pet is shown on a homemade dog run. The photograph below shows the coyote doing what coyotes do—his famous howl. Herb Hilkins shared the family story about an incident when the pet took a roast from the car after the family returned from the store and unknowingly left the car door open. (Both, courtesy of the Herb Hilkins family collection.)

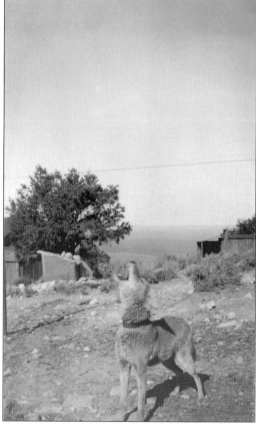

This is Lorraine Goeglein and her pet coyote. This image was taken on the south crater rim next to the Goegleins living quarters. The pole to the left and crossing wire was their homemade dog run, built by the Goegleins for the coyote. (Courtesy of the Herb Hilkins family collection.)

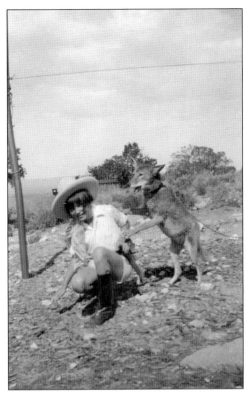

Ralph found this antelope abandoned as a baby, and like the coyote, the family adopted the animal. Apparently, the mother was killed and the baby was left alone. When they brought the baby to their Meteor Crater living quarters, they initially had to feed the animal with a bottle. The animal lived with the Goegleins for an unspecified time and eventually left, heading back into the wild. (Courtesy of the Herb Hilkins family collection.)

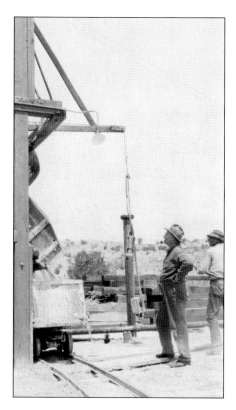

This drilling rig, shown in action, is thought to have been located on the south rim of the crater. Several shafts were drilled around Meteor Crater in an effort to locate and extract the meteorite pieces, thought to be abundant. Drilling shafts were located across the crater floor as well. (Courtesy of the Herb Hilkins family collection.)

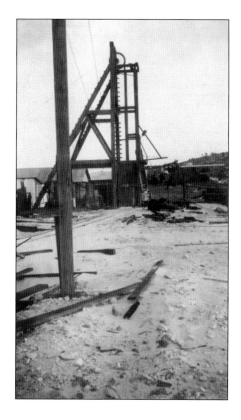

This is a wider view of the drilling shaft located on the crater south rim. Drilling eventually had to be halted due to lack of funds after a drill bit was damaged when it struck what was thought, but never proven, to be a meteorite fragment. (Courtesy of the Herb Hilkins family collection.)

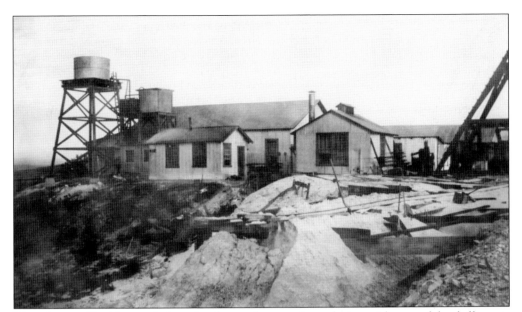

This cluster of buildings is believed to be on the crater's south rim, with part of the drilling rig showing on the right. The buildings included a mess hall where the drillers and other workmen ate their meals, some warehouse buildings, and the living quarters. A water tower in the back left overlooks the buildings. (Courtesy of the Herb Hilkins family collection.)

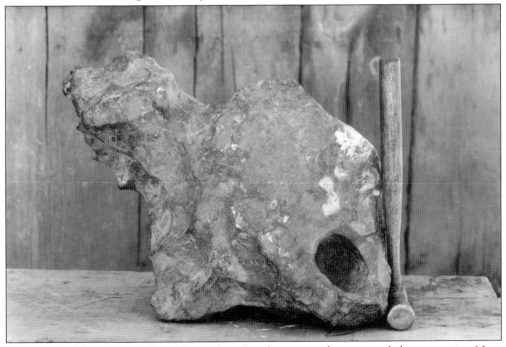

This is a sizable meteorite found by Walter Goeglein somewhere around the crater rim. Note the hammer and handle size to the right of the meteorite for scale. Herb Hilkins estimates this piece weighed around 300 pounds. According to Hilkins, there was not any interest in the meteorite, and it was eventually sold to a university in Germany. (Courtesy of the Herb Hilkins family collection.)

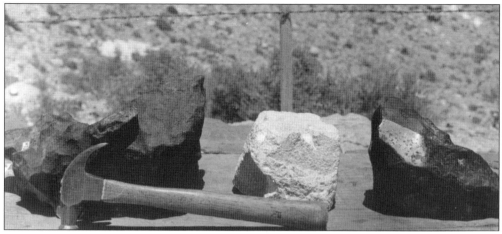

According to Herb Hilkins, these are two meteorites flanking a piece of lechatelierite found by Walter Goeglein and son Ralph somewhere around the Meteor Crater rim. Walter would cut and polish some of the rocks using the lechatelierite sand, which is fused sandstone. (Courtesy of the Herb Hilkins family collection.)

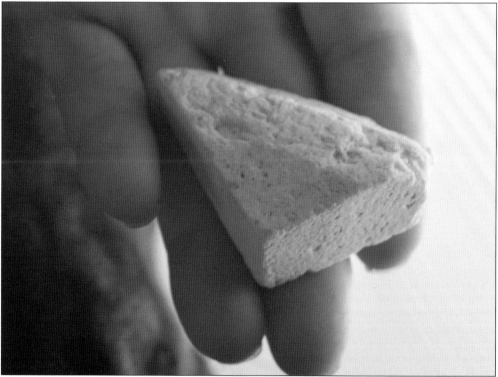

This piece of lechatelierite being held by Herb Hilkins was one of many found by the Goeglein family during their years at Meteor Crater. The family also saved lechatelierite powder that Walter used to make laundry soap. The mineral was formed during the impact of the meteorite into a layer of Coconino sandstone at Meteor Crater. During the rapid pressure reduction following the meteorite impact, steam expanded the newly formed lechatelierite. The shattered and expanded glass has a density less than that of water. (Author's collection.)

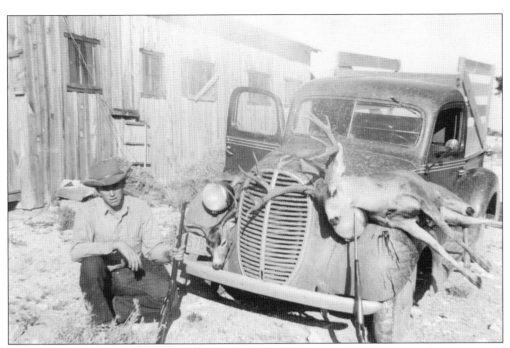

This is Ralph Goeglein with family dinner. It is believed this photograph was taken next to their living quarters on the south rim. During the Depression, hunting deer, antelope, and rabbits was common for the family due to the isolation of the location. (Courtesy of the Herb Hilkins family collection.)

This is Rimmy Jim Giddings, owner of the Rimmy Jim's gas station and store, located along Route 66 around the 1930s. The facility was at the junction of Meteor Crater Road and Route 66. In Route 66's heyday, there were six trading posts between Winona and Winslow, including Twin Arrows, Toonerville, Two Guns, Rimmy Jim's, Meteor City, and Hopi House. Lorraine and Doris would sometimes ride their burro to Rimmy Jim's to buy and split a 5¢ soda. Giddings passed away in 1943. (Courtesy of the Herb Hilkins family collection.)

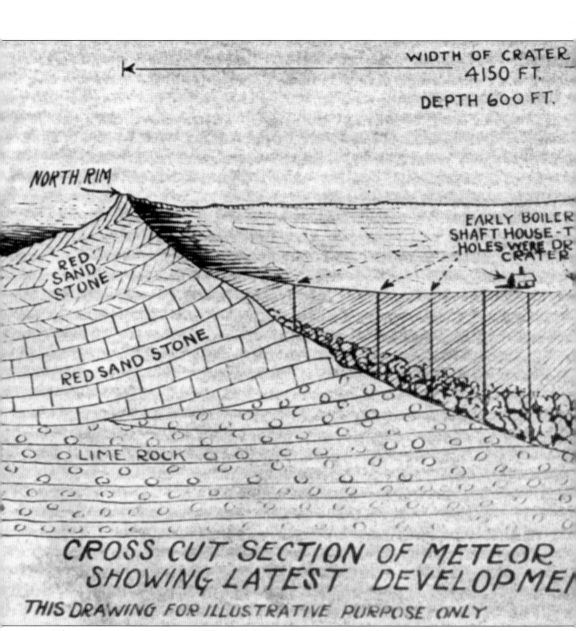

WIDTH OF CRATER
4150 FT.

DEPTH 600 FT.

NORTH RIM

EARLY BOILER
SHAFT HOUSE - T
HOLES WERE DR
CRATER

RED SAND STONE

RED SAND STONE

LIME ROCK

CROSS CUT SECTION OF METEOR
SHOWING LATEST DEVELOPMEI
THIS DRAWING FOR ILLUSTRATIVE PURPOSE ONLY

This is a cross-section view of Meteor Crater showing where the meteor mass supposedly rests. There were 26 holes drilled inside the crater in addition to the drilling operations on the south rim, shown in the far right of this image. The illustration's origin is unknown, but in the lower

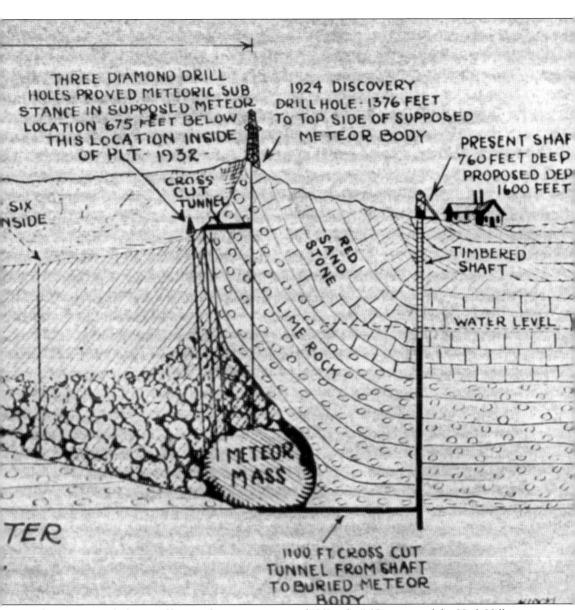

right corner is a light set of letters that appears to read "HLocke." (Courtesy of the Herb Hilkins family collection.)

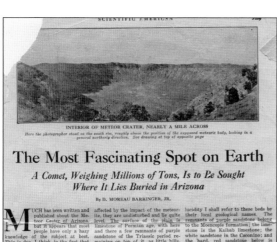

INTERIOR OF METEOR CRATER, NEARLY A MILE ACROSS
Here the photographer stood on the south rim, roughly above the position of the exposed meteoric body, looking in a general northerly direction. See drawing at top of opposite page

The Most Fascinating Spot on Earth

A Comet, Weighing Millions of Tons, Is to Be Sought Where It Lies Buried in Arizona

By D. MOREAU BARRINGER, JR.

MUCH has been written and published about the Meteor Crater of Arizona, but it appears that most people have only a hazy knowledge of the subject at best. This is due, I think, to the fact that the technical publications about it have never had wide circulation; and to the fact that the more popular articles on the subject which have appeared from time to time have often been woefully distorted. It is a subject that seems to challenge the imagination of the average newspaper writer, and several of them have entirely outdone the actual facts in their sensational descriptions of it.

The physical aspects of the Crater are simple. In a flat, treeless plain there is a round hole, surrounded by a raised rim of crushed rock. The hole is about four-fifths of a mile in diameter, and some 450 feet deep, not counting the height of the rim, which rises on an average 129 feet above the plain. This makes the total depth of the hole below the crater's rim about 570 feet.

The geological formations of the region are also simple, being horizontal sedimentary rocks. Except where

affected by the impact of the meteorite, they are undisturbed and lie quite level. The surface of the plain is limestone of Permian age, with here and there a few remnants of purple sandstone of the Triassic period remaining on top of it, as little hills. Below the limestone, which is about 250 feet thick, lie a thousand feet of

soft, white sandstone, also Permian. The lowest members of this bed have a yellowish or brownish tinge, but the great majority of it is white. Below this lies an indeterminate thickness of hard, red sandstone, quite different in both structure and hardness from the white sandstone above. It is either Permian or upper Carboniferous. For greater

lucidity I shall refer to these beds by their local geological names. The remnants of purple sandstone belong to the Moencopie formation; the limestone is the Kaibab limestone; the white sandstone is the Coconino; and the hard, red sandstone below is known as the Supai formation, or more commonly, as the "Red Beds."

Except in the neighborhood of the Crater, these rocks, as I have said, are lying level and undisturbed. Around the edges of the hole, however, they are greatly cracked and broken, and have been raised up so as to slope radially away from the hole in all directions. Those rocks which once occupied the hole itself have been smashed into fragments of all sizes and thrown into the air, from whence some of them fell back into the hole, partly filling it, the remainder being scattered and piled up around the rim.

Mixed with these fragments around the hole and on the plain a short distance from it there have been found a far greater number of iron meteorites than have been found on all the rest of the earth's surface put together. And, what is even more striking, the closer you get to the hole the

Science Backs Meteor Crater

Because certain people, reluctant to believe the unprecedented, regard as sensational the theory that Meteor Crater was formed by the impact of a giant meteor which struck the earth, we have obtained the following definite statements from two well-known scientists:

"I am perfectly willing to make a strong affirmative statement in support of Mr. Barringer's article," writes Dr. W. F. Magie of the Palmer Physical Laboratory, Princeton University, "but there ought to be no need for it. There is no reasonable doubt that the Crater was formed by the fall of a meteor and that this meteor is buried in it."

Dr. Elihu Thomson, Director of the Thomson Laboratory of the General Electric Company, writes, "I am very willing to be quoted as follows: 'There can be no question of the Crater being made by masses of meteoric iron, and that an enormous mass of such iron remains buried under the south wall of the Crater.'"

The Editor.

At left is the cover page from the July 1927 *Scientific American*. Written by D. Moreau Barringer Jr., this is one of the many pieces in Herb Hilkins's family collection from when his grandparents were the early caretakers of the site. Outside the family, not much is known about the family history during the years they worked and lived at Meteor Crater. Below, Walter Goeglein enjoys a quiet moment on the crater rim. (Both, courtesy of the Herb Hilkins family collection.)

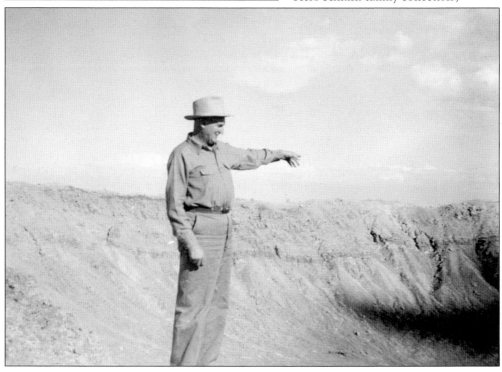

Four

THE METEORITES

Over the years, there have probably been hundreds, if not thousands, of meteorite chunks, both big and small, picked up in and around Meteor Crater. The crater originally came to the attention of scientists following its discovery by European settlers in the 19th century. Studies indicate the meteor was breaking up as it passed through Earth's atmosphere and was in a cluster made up of large and small pieces. Upon impact at 26,000 miles per hour, fragments were scattered for miles around the present-day site. Most of the meteorite was melted by the force of the impact and spread across the landscape in a very fine, nearly atomized mist of molten metal. Millions of tons of limestone and sandstone were blasted out of the crater, covering the ground for a mile in every direction with a blanket of shattered, pulverized, and partially melted rock mixed with fragments of meteoritic iron. Today, the Meteor Crater Visitor Center offers an up-close and personal look at two of the larger meteorites: the Holsinger Meteorite, the largest meteorite found to date, and an interestingly shaped meteorite known as the Basket Meteorite. The Basket Meteorite and the Verkamp Meteorite, which is presently on display in the visitor's center at Lowell Observatory in Flagstaff, Arizona, share their own interesting history of terrestrial travel since their arrival on Earth 50,000 years ago and subsequent discovery.

In the late 1940s, Ernest Chilson of the Bar T Bar Ranch discovered the Basket Meteorite while riding the ranch a few miles west of Meteor Crater. In 1942, at the age of 26, he became general manager of the Bar T Bar Ranch, and in 1957, he was made president of Meteor Crater Enterprises. He held both positions until retirement in 1981. The meteorite was stolen in 1968 but was returned on March 23, 2009. (Courtesy of the Judy Chilson Prosser collection.)

This is an earlier image of the Basket Meteorite, thought to be a postcard sold in the marketing of Meteor Crater. It is easy to see how the meteorite got its name. This interesting-looking piece weighs 49 pounds. (Courtesy of Meteor Crater Enterprises, Inc., collection.)

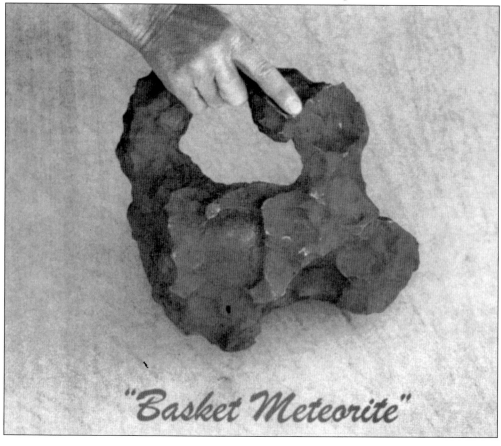

"Basket Meteorite"

Dr. Paul Sipiera is pictured in the Thiel Mountains of Antarctica in 2000 during the Planetary Studies Foundation's second expedition in search of meteorites. The meteorite in the lower part of the photograph is a 400-gram-plus stone meteorite. In 2008, Dr. Sipiera was asked to look at a rock thought to be a meteorite. Additional research led to the discovery of a vintage postcard showing the Basket Meteorite. In 2009, it was returned to Meteor Crater thanks to Dr. Sipiera. Dr. Sipiera is president and chief executive officer of the Planetary Studies Foundation and director of its Earth & Space Science Museum in Elizabeth, Illinois. (Photograph by William J. Gruber, courtesy of Dr. Paul Sipiera.)

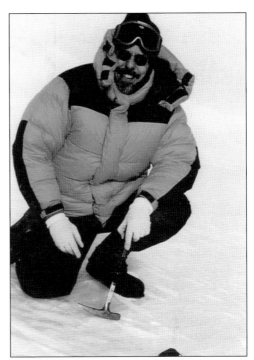

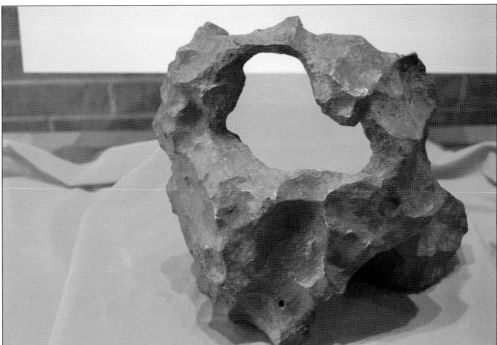

The Basket Meteorite is shown on display, now safely back at Meteor Crater. It remains a mystery as to who stole the meteorite and why it was stolen. Even more amazing is the story of the gentleman from Wisconsin who purchased the object at a garage sale and personally delivered it back to the Meteor Crater. It has been reported he could have sold the meteorite for $10,000 or more. (Author's collection.)

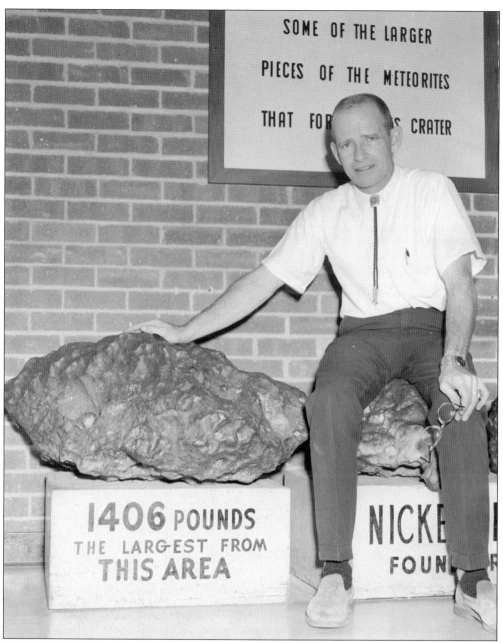

The Holsinger Meteorite, recovered at the site, is shown on display at the Meteor Crater Museum around the 1950s with an unidentified individual. The meteorite is the largest fragment found to date. There are other large meteorite fragments in museums around the world. They include the 1,069-pound fragment housed in Canterbury Museum in Christchurch, New Zealand, and a 790-pound meteorite housed at the Muséum d'Histoire naturelle in Paris. (Courtesy of Meteor Crater Enterprises, Inc., collection.)

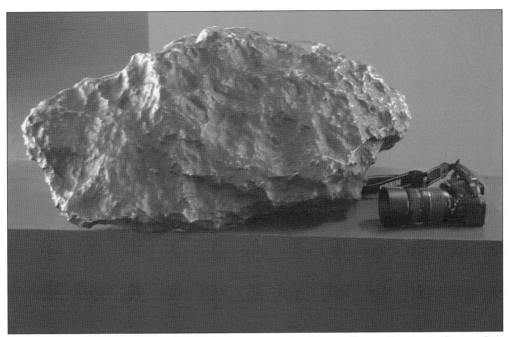

The Holsinger Meteorite is on display at the present-day Meteor Crater Discovery Center. It is believed the piece, like many fragments, broke away from the main 300,000-ton meteor as it entered the atmosphere and, after separating, struck the earth away from the main impact crater. It was reportedly found around two miles north of the crater rim in 1911. (Author's collection.)

The Verkamp Meteorite, weighing 535 pounds, is shown on display at the Verkamp Trading Post, located at the Grand Canyon, prior to removal and transport to Lowell Observatory. Stephen Verkamp related that when the meteorite was on display outside of the Verkamp Trading Post at the Grand Canyon it was actually stolen twice but thankfully found its way back to the Verkamp store. Special thanks go to Stephen Verkamp. (Courtesy of Kevin Schindler, Lowell Observatory.)

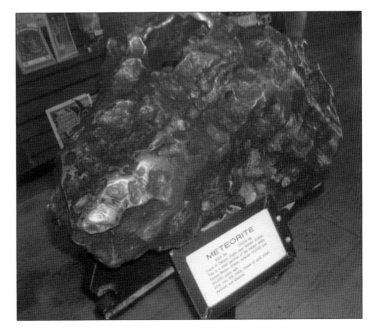

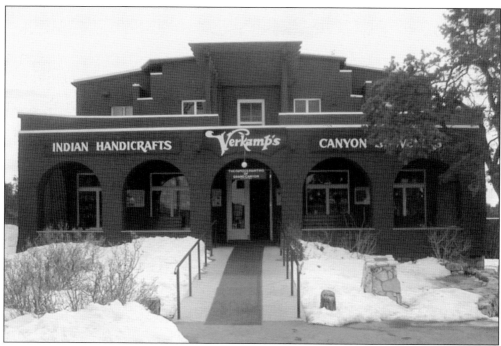

These are two images of Verkamp's Trading Post in late 2008, after the closing of the store. Stephen Verkamp, along with Kevin Schindler and others from Lowell Observatory, was on-site to remove the Verkamp Meteorite display in preparation for transporting the fragment to its new home at Lowell Observatory. Before being moved indoors, the meteorite was on display for many years just to the right of the entry. (Both, courtesy of Kevin Schindler, Lowell Observatory.)

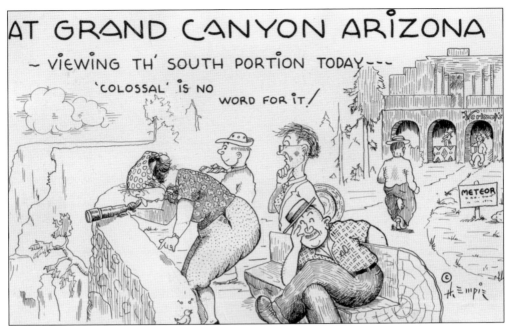

This vintage postcard was drawn by well-known artist Hal Empie. Notice the "Meteor" sign in front of Verkamp Trading Post to the right of the pathway. Empie Kartoon Kards is one of the first copyrights for Western cartoon postcards. Arizona native Hal Empie originated these designs during the early 1930s in Duncan, Arizona. His originals are preserved at the Carnegie Library at Syracuse University. Special thanks go to the Hal Empie Gallery, Tubac, Arizona. (Courtesy of the Stephen Verkamp collection.)

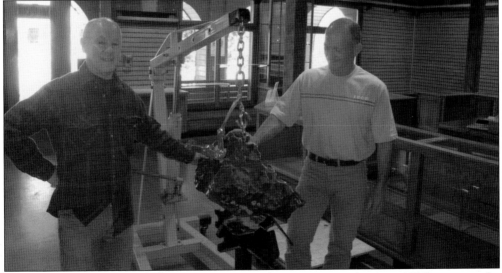

Stephen Verkamp (left) and Ralph Nye of Lowell Observatory are shown in 2008 removing the Verkamp Meteorite in preparation for transport to Lowell Observatory. In 1906, John George Verkamp set up a tent at the south rim of the Grand Canyon and sold souvenirs to tourists. He acquired a meteorite from a neighbor not long after he opened for business. In 2008, the Verkamp family decided to close the shop after 102 years of operation, and they decided to offer meteorite to Lowell Observatory. (Courtesy of Kevin Schindler, Lowell Observatory.)

Above, the Verkamp Meteorite is loaded and ready for the trip to Flagstaff, Arizona, and delivery to its future home at Lowell Observatory on Mars Hill. Below, Ralph Nye with Lowell Observatory (left) and Stephen Verkamp bid a final farewell to the Grand Canyon and the Verkamp Trading Post. It is not known for certain how the meteorite originally traveled from the Diablo Canyon and Meteor Crater region to the Grand Canyon. (Both, courtesy of Kevin Schindler, Lowell Observatory.)

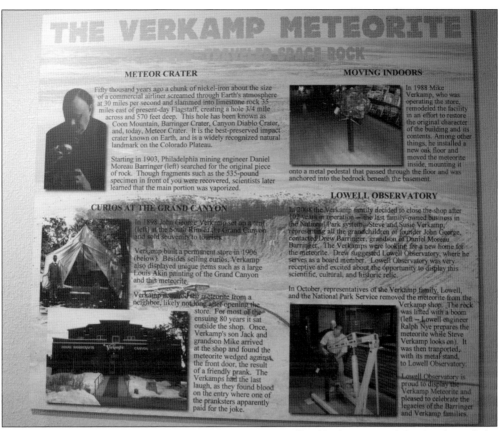

This illustration, located behind the meteorite at Lowell, tells the story of the family and the meteorite. The Babbitt and Verkamp families came west at about the same time and established themselves in the Flagstaff/Grand Canyon area. John G. Verkamp and his wife, Catherine (née Wolfe), began construction of the store on Grand Canyon's south rim in 1905, fifteen years before the establishment of the national park, and opened for business on January 31, 1906. (Author's collection.)

Carolyn Shoemaker, wife of Eugene "Gene" Shoemaker, and Drew Barringer, grandson of Daniel Barringer, check out the Verkamp Meteorite during the unveiling at Lowell Observatory on June 8, 2009. Shoemaker is a remarkable woman and an amazing astronomer; she holds the record for the most comet discoveries, having found more than 800 asteroids and 32 comets. Additional fame comes from her co-discovery— with her husband and David Levy—of Comet Shoemaker–Levy 9 in 1993. (Photograph by Jake Bacon, *Arizona Daily Sun*, courtesy of Kevin Schindler, Lowell Observatory.)

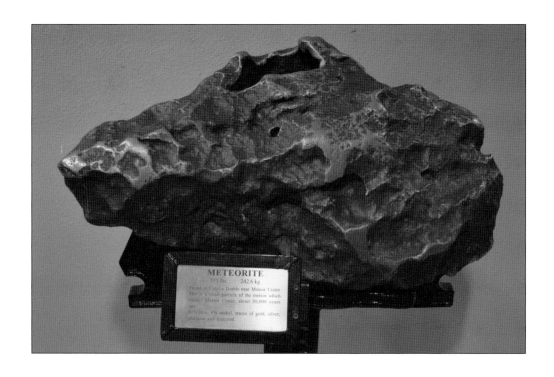

The Verkamp Meteorite is shown here on display at the Lowell Observatory Visitor Center in Flagstaff, Arizona. Below is the Verkamp Meteorite plaque, providing the weight and some of the meteorite's history and mineral information. The meteorite was dedicated to Lowell Observatory in 2009. (Both, author's collection.)

METEORITE
535 lbs 242.6 kg

Found in Canyon Diablo near Meteor Crater. This is a small particle of the meteor which formed Meteor Crater, about 50,000 years ago.
92% iron, 8% nickel, traces of gold, silver, platinum and diamond.

Five

PREPARING FOR THE MOON AND BEYOND

In his book *Taking Science to the Moon: Lunar Experiments and the Apollo Program* (© 2001 The Johns Hopkins University Press, pp. 58–77. Text reprinted with permission of Johns Hopkins University Press.), Donald Beattie writes:

In the 1960s and 1970s, northern Arizona likely earned a de facto Emmy for its part in the Space Race. Its volcanic terrain and geologic composition put it near the center of the lunar training program for the United States Apollo Missions. Apollo astronauts, including Neil Armstrong and Buzz Aldrin, imagined the northern Arizona landscape as the moon. The United States Geological Survey (USGS) established its Astrogeology Science Center in Flagstaff, and the area became a blueprint for the Apollo missions. The Astrogeology Research Program started in 1963 when USGS and National Aeronautics and Space Administration (NASA) scientists transformed the northern Arizona landscape into a re-creation of the Moon. They blasted hundreds of different-sized craters in the earth to form the Cinder Lake crater field, creating an ideal training ground for astronauts. Using the cinder cones and craters scattered around northern Arizona as models, USGS and NASA scientists, including Eugene Shoemaker, taught astronauts about geologic features and lunar formations. They gave lectures and led field exercises at the Cinder Lake crater field, southeast of Flagstaff, as well as the Grand Canyon, Sunset Crater, Meteor Crater, and Lowell Observatory. Astronauts ran lunar rover simulations and practiced soil sampling techniques wearing replica space suits in the shadows of the San Francisco Peaks. The training gave them the skills essential for the first successful manned missions to the moon. Some scholars also credit the Apollo Missions and the Astrogeology Science Center with advancing human understanding of lunar and terrestrial craters and their origins. Scientists traced the formation of lunar and terrestrial craters, including Meteor Crater, to large impacts with objects hurling through space. Further research led to the discovery of previously unidentified ancient craters at Sierra Madera in Texas, the Chesapeake Bay marine impact crater, and the crater in southeastern Nevada. Today, the Astrogeology Science Center still operates, but largely without the fame. Tourists can get some of the Apollo Mission experience at Meteor Crater where the public can relive the Apollo training program through photographs and other related displays.

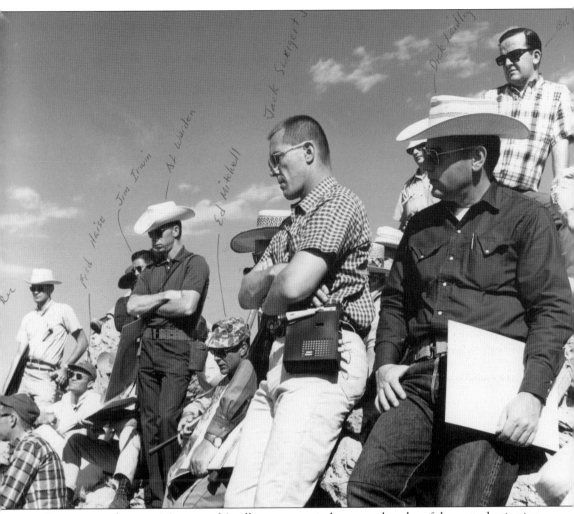

Spacemen at the crater! A group of Apollo astronauts is shown on the edge of the crater beginning training in geology in preparation for trips to the moon's surface. Included in the photograph is Jack Swigert (arms crossed in checkered shirt), who would be a last-minute replacement and command module pilot on the ill-fated Apollo 13. Also pictured are Fred Haise (sitting to the left in sunglasses and a baseball cap), later the lunar module pilot on Apollo 13, and Ed Mitchell (sitting in lower center with a camouflage hat), who would be the lunar module pilot on Apollo 14 and the sixth man to walk on the moon. The astronauts also worked with the scientists at neighboring Lowell Observatory in Flagstaff in mapping the moon, and the resulting maps were used as training aids by the astronauts. (Courtesy of Meteor Crater Enterprises, Inc., collection.)

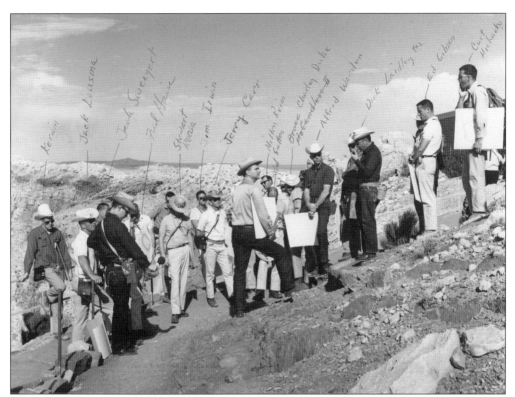

The Apollo astronauts are out for another day of geological training. The individual in the foreground at center with his back to camera is Dr. Eugene "Gene" Shoemaker. His first job out of college was as a USGS geologist prospecting for uranium during the post–World War II atomic energy boom. Shoemaker's designated search area was the desert Southwest, in the Four Corners region—primarily Arizona and New Mexico. While there, he honed what would become a lifelong commitment to fieldwork. He also visited Meteor Crater and proposed that it was the result of an asteroid impact. In 1961, Shoemaker founded the Astrogeology Center of the USGS in Flagstaff and, as shown here, was instrumental in training the astronauts who would be tasked with carrying out research on the moon's surface. Below is one of the NASA Apollo shoulder patches. (Both, courtesy of Meteor Crater Enterprises, Inc., collection.)

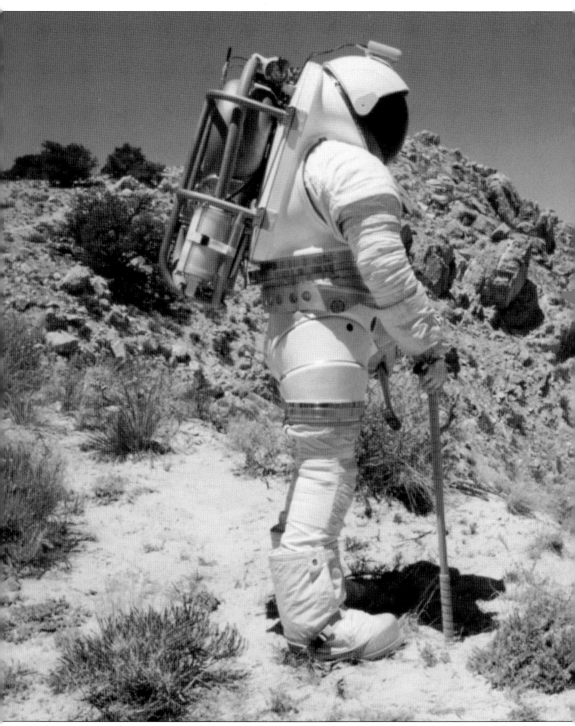

Astronauts and geologists continue testing suits at Meteor Crater. The photograph was taken by NASA in the late 1990s during the testing of advanced spacesuits (see cover). The suit is being tested by Dr. Dean Eppler with NASA. Developing and subsequent testing of the suits at the site with the support of Meteor Crater personnel was and continues to be a vital piece in supporting

the completion of NASA team exercises. From the early years of the space race into the 21st century, the site has been frequented by NASA and others in preparation for trips to the moon and future travel to Mars. Special thanks go to Dr. Dean Eppler. (Courtesy of Meteor Crater Enterprises, Inc., collection.)

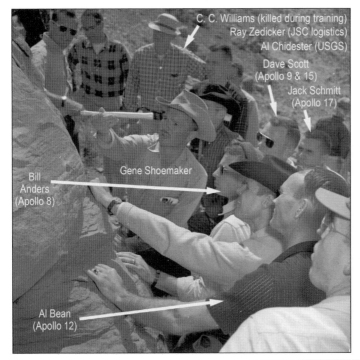

C. C. Williams (killed during training)
Ray Zedicker (JSC logistics)
Al Chidester (USGS)
Dave Scott (Apollo 9 & 15)
Jack Schmitt (Apollo 17)
Gene Shoemaker
Bill Anders (Apollo 8)
Al Bean (Apollo 12)

This image of Dr. Shoemaker and the astronauts was scanned by Johnson Space Center. Dr. David Kring annotated the picture to identify participants. Bill Anders flew as lunar module pilot for the Apollo 8 mission. Al Bean (Apollo 12) was the lunar module pilot in November 1969. In December 1972, Jack Schmitt, a geologist, flew on board Apollo 17. Schmitt became NASA's first scientist-astronaut to fly in space. Dave Scott flew on Apollo 9 and Apollo 15. (Courtesy of Dr. David Kring, NASA, Johnson Space Center, photograph S65-23562.)

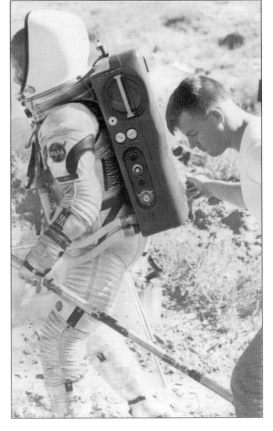

An unidentified NASA team member trains in the area in 1969 in preparation for the planned Apollo moon landings. It is believed this may be at the Hopi Buttes. Conditions at Meteor Crater and the surrounding region are similar to those found on the moon, and NASA used the area often as the official training site for Apollo astronauts. Special thanks go to Dr. Dean Eppler and Joe Kosmo. (Courtesy of Meteor Crater Enterprises, Inc., collection.)

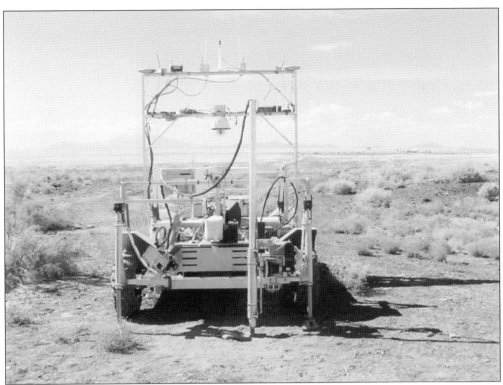

Above is a test lunar rover vehicle outside the Meteor Crater rim in preparation for testing by NASA and/or USGS personnel. The model was used in testing for the extravehicular activity (EVA) planned for the Apollo moon landings. At right, a member of the team takes the rover for a spin. (Both, courtesy of Meteor Crater Enterprises, Inc., collection.)

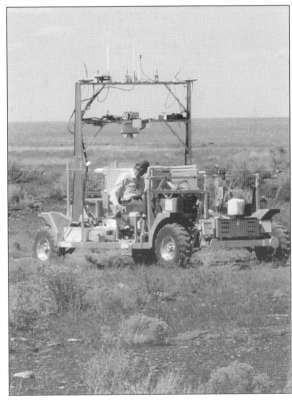

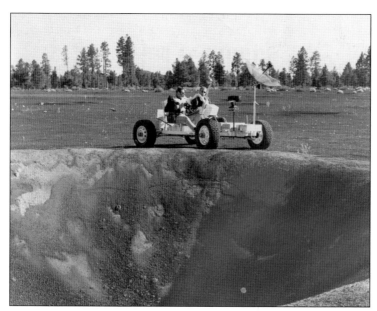

This is Apollo 15 training at Cinder Crater outside of Flagstaff, to the west of Meteor Crater. Astronaut James B. Irwin, lunar module pilot (left), and David R. Scott, commander (right), are conducting EVA training in a lunar rover simulator. The mission, from July 26– August 7, 1971, included 18.5 hours of EVA. (Courtesy of Meteor Crater Enterprises, Inc., collection.)

This is a tribute to Dr. David John Roddy. Dr. Roddy was involved in the astronaut training effort at Meteor Crater. He was also involved in a drilling project at Meteor Crater and was at the forefront of investigators studying impact and explosion craters. His work assisted in the recognition of large-body impact as an important geologic process on Earth. Special thanks go to David S.F. Portree, USGS, Flagstaff. (Courtesy of Meteor Crater Enterprises, Inc., collection.)

Eugene Shoemaker gestures during another day of training the Apollo astronauts at Meteor Crater in preparation for their missions to the moon. On January 6, 1998, some of Dr. Shoemaker's ashes were carried to the moon by the Lunar Prospector space probe along with a tribute, engraved on brass foil, designed by Dr. Carolyn Porco. Lunar Prospector, along with Shoemaker's ashes, crash landed into the lunar south pole on July 31, 1999. It was Dr. Porco's idea to honor Shoemaker and his legendary contributions to planetary science by sending his ashes to the moon, and she designed the tribute in its entirety: conceiving the idea, convincing NASA officials to do it, choosing and arranging all the elements in the design, overseeing the engraving of the foil and the capsule containing his ashes, and ultimately delivering it to NASA for inclusion on the spacecraft. The story is told in the article "Destination Moon" in the February 2000 issue of *Astronomy Magazine*. (Courtesy of Dr. Carolyn Porco and the Astrogeology Team, USGS, Flagstaff, Arizona.)

This sign announcing "Astronauts Training" was a common sight at Meteor Crater in the 1960s and 1970s. The announcement was intended to alert the visitors and maintain a respect for the training exercises with minimum interruption to NASA and USGS personnel and the astronauts. (Courtesy of Meteor Crater Enterprises, Inc., collection.)

Meteor Crater draws visitors from around the world every year. Here are three examples used for marketing the site. From left to right are English, German, and Japanese brochures. When the author took a tour in the spring of 2015, he met visitors from Holland, Ireland, and India. (Courtesy of Meteor Crater Enterprises, Inc., collection.)

Alan Shepard (left) is shown with Gene Collier, Meteor Crater site manager, on the rim of the crater in the 1980s. Shephard was the first American in space on May 5, 1961, and commanded Apollo 14 in February 1971. He holds the distinction of being the only recorded human to date to hit a golf ball on the moon (he actually hit two using a modified 6 iron). Special thanks go to Gene and Betty Collier. (Courtesy of Meteor Crater Enterprises, Inc., collection.)

Pictured at the Astronaut Wall of Fame are, from left to right, Ed Lu, chairman of the B612 Foundation, a nonprofit organization whose goal is to predict and prevent catastrophic asteroid impacts on Earth; Brad Andes, president of Meteor Crater Enterprises, Inc.; Rusty Schweickart; and Dennis Tito. Lu led the Advanced Projects Group at Google for imaging the street view and Google Maps. Prior to Google, he was a 12-year astronaut with NASA and flew on three space missions, logging over 206 days in space. Rusty Schweickart, the first Apollo lunar lander pilot, was chosen as part of NASA Astronaut Group Three in October 1963 and was on the crew of Apollo 9 in March 1969. Dennis Tito, the first space tourist, paid $20 million to be taken up by a Russian Soyuz spacecraft to spend eight days on the ISS (International Space Station) in 2001. Special thanks go to Danica Remy with the B612 Foundation. (Courtesy of Meteor Crater Enterprises, Inc., collection.)

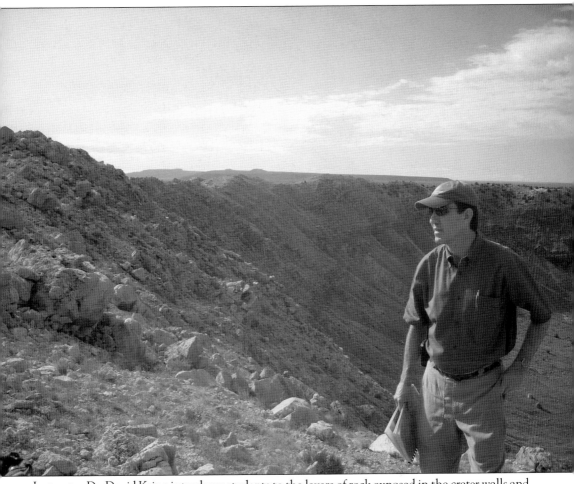

Instructor Dr. David Kring introduces students to the layers of rock exposed in the crater walls and how the multi-megaton impact event deformed those layers while, at the same time, excavating 175 million metric tons of rock to form Meteor Crater's bowl-shaped cavity. Dr. Kring organized the field camp through the Center for Lunar Science and Exploration, which is a division of the Lunar and Planetary Institute (founded by President Johnson and chartered by the National Academy of Sciences in 1969), as part of Dr. Kring's effort to train a new generation of explorers for the moon and beyond. The Field Training and Research Program at Meteor Crater is a weeklong field class and research project. The goal of the field camp is to introduce students to impact cratering processes and provide an opportunity to assist with a research project at the crater. (Photograph by Emily Worsham, courtesy of Dr. David Kring.)

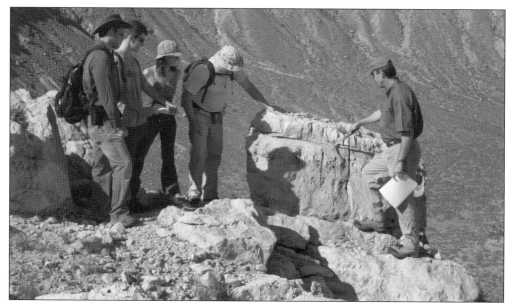

The program founder of the Field Training and Research Program at Meteor Crater, Dr. David Kring, on the far right, is shown with his students discussing a block of limestone that was ejected from the crater when it formed 50,000 years ago. As part of the 2011 training phase of the program, students measured the ejected blocks of rock and calculated the time it took for blocks to make their ballistic flights and land on the surrounding landscape. (Photograph by Joshua Garber, courtesy of Dr. David Kring.)

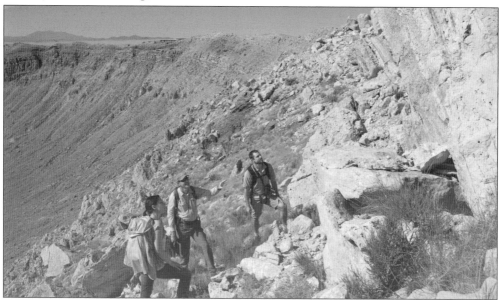

Instructor Dr. David Kring, center and pointing, is shown with two of his students on the eastern wall of the Meteor Crater rim, where they are examining multiton blocks of debris that landed after being launched upward and flipped over by the meteorite impact event. Dr. Kring originally organized the field camp with support from NASA's Lunar Science Institute and, more recently, with support from NASA's Solar System Exploration Research Virtual Institute. (Photograph by Mike Zanetti, courtesy of Dr. David Kring.)

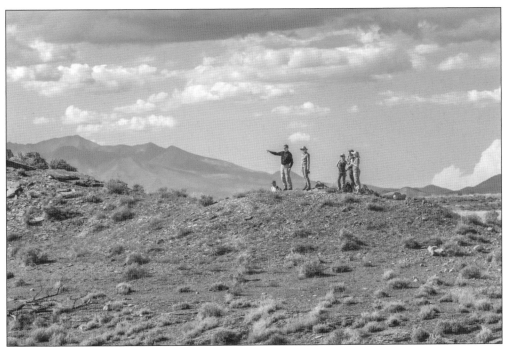

Dr. David Kring stands on a ridge north of Meteor Crater pointing to the source of impact debris during the 2014 Field Training and Research Program. The students were studying impact ejecta that landed at high speeds and skated on the upper ridge. The camp introduces students to impact cratering processes and provides an opportunity to assist with a research project at the crater. Skills developed during the field camp are designed to prepare students for their own thesis studies. (Photograph by Aaron Boyd, courtesy of Dr. David Kring.)

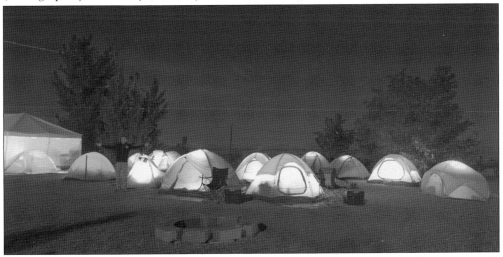

Dr. David Kring stands near the student dining hall and classroom in the far left of the photograph. This campsite was set up at the Meteor Crater RV Park for the 2014 Field Training and Research Program. The program visited the crater in 2010, 2011, and 2014 and is scheduled for 2016. Thus far, nearly 60 students from the United States, Austria, Canada, Germany, and the United Kingdom have participated. The results are presented in the form of two-page abstracts at the Lunar and Planetary Science Conference. (Photograph by Aaron Boyd, courtesy of Dr. David Kring.)

Dr. Kring is pictured on the crater floor. In addition to his Field Training and Research Program at Meteor Crater, Dr. Kring, with the Center for Lunar Science and Exploration, also initiated new programs that integrate science with the human exploration component of NASA. That is an important task as NASA builds a space program that carries astronauts out of low-earth orbit to deep space, where they will work on planetary surfaces. One of his tasks is to train these new classes of astronauts. (Courtesy of Dr. David Kring.)

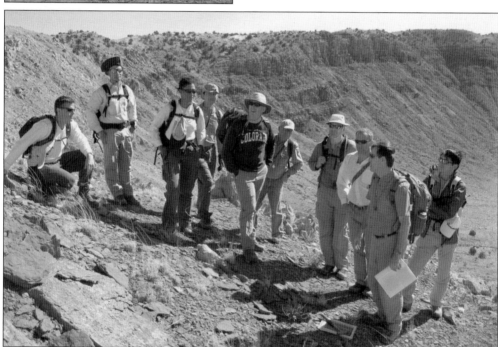

Dr. David Kring, on the right with document in hand, and Dr. Friedrich Hörz are shown here with the 2009 class of NASA, Canadian Space Agency (CSA), and Japan Aerospace Exploration Agency (JAXA) astronauts just below the rim of the Barringer Meteorite Crater discussing the geological makeup of the impact crater. (Photograph by Kjell Lindgren, NASA, courtesy of Dr. David Kring.)

Dr. David Kring (left) and Dr. Friedrich Hörz train members of the 2009 class of NASA, CSA, and JAXA astronauts at Meteor Crater. They are on the rim of the crater discussing its geology and strategies to explore similar structures on the moon and elsewhere in the solar system. Hörz was also a trainer for the Apollo 16 crew. (Photograph by Debbie Trainor from the NASA, Johnson Space Center Astronaut Office, courtesy of Dr. David Kring.)

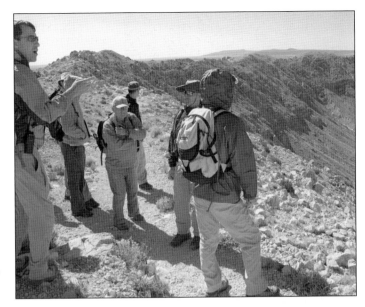

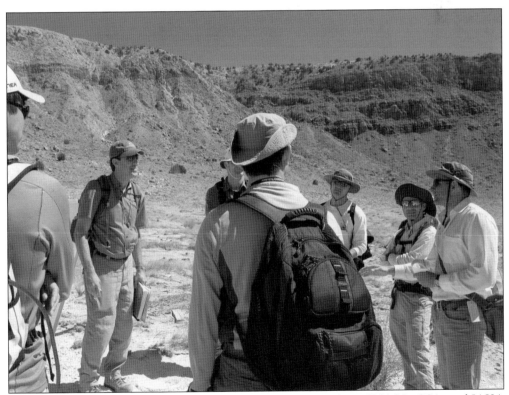

Dr. David Kring discusses geology with members of the 2009 class of NASA, CSA, and JAXA astronauts on the floor of Barringer Meteorite Crater in April 2011. Kring is a science advisor for the Barringer Crater Company and was asked by the company to assume the duties and responsibilities of Gene Shoemaker after he passed away. (Photograph by Debbie Trainor from the NASA, Johnson Space Center Astronaut Office, courtesy of Dr. David Kring.)

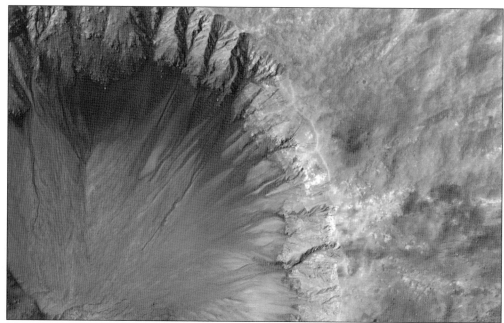

The photograph above shows a Mars look-alike impact crater, that, according to the scientists, appears relatively recent, as it has a sharp rim and well-preserved ejecta. The crater is a little more than one kilometer or .625 miles wide. The word *recent* is used on a geological scale. This crater on Mars is quite old on a human scale. Below is an aerial photograph of the Meteor Crater south rim showing similarities of the two impact craters. (Above, courtesy of NASA/JPL/University of Arizona High Resolution Imaging Science Experiment [HiRISE] Mars Reconnaissance Orbiter; below, courtesy of Meteor Crater Enterprises, Inc., collection.)

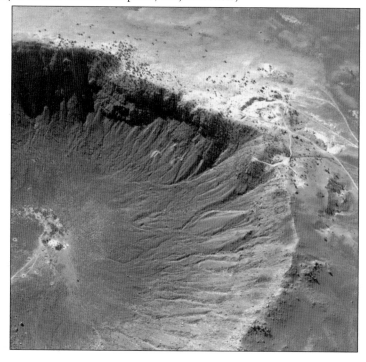

Six

VISITORS FROM
NEXT DOOR AND
AROUND THE WORLD

Each year, Meteor Crater is visited by people from as close as neighboring Winslow to far-reaching places across the globe. Approximately 250,000 visitors annually are treated to a first-rate visitor center, and tours along the rim trail are available daily excepting Christmas Day. The wide variety of past visitors includes students from nearby schools on field trips and Apollo astronauts in training who later walked on the moon, as well as movie and television stars and even Elvis Presley, the king of rock and roll, who stopped by for a visit in 1967. Guests will find the visitor center is the most extensive interactive display of meteor impact science of its type in the world. It includes guest-controlled computer simulations; a meteorite fragment weighing over 1,400 pounds; artifacts from early exploration and scientific study of the crater; high-tech graphics of space, meteorites, asteroids, and the solar system; and exhibits from Apollo astronaut training and asteroid collisions worldwide and on other planets. Meteor Crater's friendly and fascinating gift shop offers a wide variety of gift and souvenir items from fossils and dinosaurs to astronauts and spacecraft. Focusing on the unique Meteor Crater experience, gifts and souvenirs include Native American and gem jewelry; authentic fossils; astronaut ice cream and mission patches; space toys; games; postcards; space and geology science kits; books; home decorations; and Meteor Crater T-shirts, sweatshirts, and hats. The sandwich shop in the visitor center offers lunch, snacks, and soft drinks with indoor seating for the whole family. An actual Apollo test capsule and American Astronaut Wall of Fame are the highlights of the Astronaut Park, just outside the sandwich and gift shop. The park is a perfect place for a pause and family picnic, as well as an opportunity to sample the weather and unique beauty of Northern Arizona's high desert plateau.

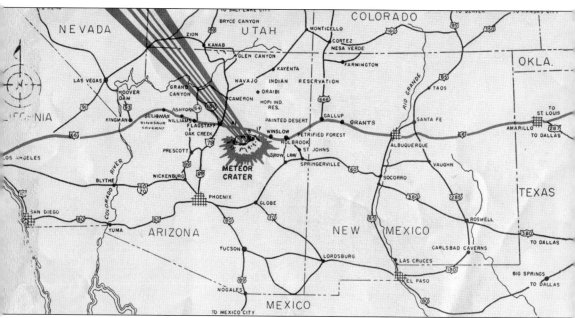

This is an early map of the Meteor Crater impact location in northeastern Arizona. Notice US Route 66 running from Texas to the California coast. Neither Interstate 40 replacing the "Mother Road" nor Interstate 17 connecting Flagstaff to Phoenix was completed when this map was distributed. The site is located 18 miles west of Winslow on Interstate 40 at exit 233, just six miles south of the interstate on a paved road and easily assessable. Tours of the museum and out to the crater rim are provided each day. (Courtesy of Meteor Crater Enterprises, Inc., collection.)

This view of the west rim was taken from Interstate 40. If someone did not know the 550-foot-plus-deep impact crater was just over the visible rim, he or she might think the rim was but one of the many mesas or buttes found throughout the Northern Arizona landscape. (Author's collection.)

People approaching Meteor Crater on Interstate 40 will pass a few of these signs. If one chooses to tune in, the announcer will provide a detailed history and explanation of the Meter Crater impact site. This photograph was taken driving east out of Flagstaff, west of the Meteor Crater exit. (Author's collection.)

When driving into the site on Meteor Crater road, don't speed! Only meteors are allowed to exceed the 50-mile-per-hour speed limit, and the road is heavily patrolled. This is one of many creative signs located on Meteor Crater Road leading into the impact site. (Author's collection.)

Watch out! This is another clever sign. The illustration is available in the Meteor Crater Visitor Center gift shop along with other memorable merchandise. (Author's collection.)

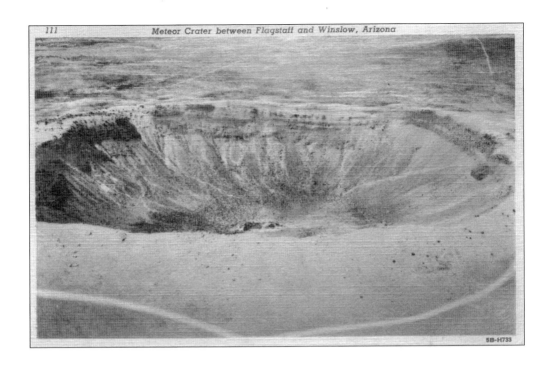

This early postcard illustration shows an aerial view of Meteor Crater. Notice the back of the card (below) for placement of the required 1¢ postage. Privately printed 1¢ postcards were issued from 1898 through 1916. Postage was raised to 2¢ during World War I and again dropped to 1¢ after the war. (Both, courtesy of the Jenny Kincade family collection.)

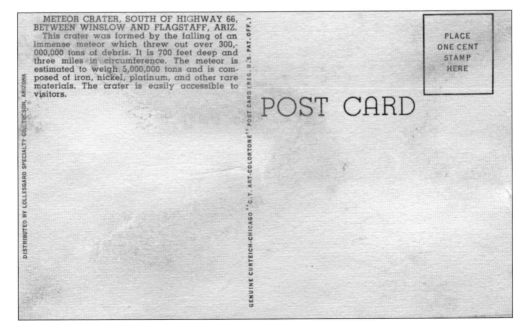

METEOR CRATER, SOUTH OF HIGHWAY 66, BETWEEN WINSLOW AND FLAGSTAFF, ARIZ.

This crater was formed by the falling of an immense meteor which threw out over 300,000,000 tons of debris. It is 700 feet deep and three miles in circumference. The meteor is estimated to weigh 5,000,000 tons and is composed of iron, nickel, platinum, and other rare materials. The crater is easily accessible to visitors.

POST CARD

PLACE ONE CENT STAMP HERE

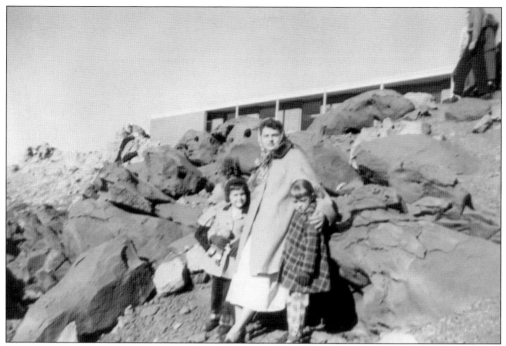

From left to right in 1957 are the author's cousin Linley Schrader, aunt Hattie Beth Schrader, and sister Anita Davis below the north rim and museum on a cool Northern Arizona December day. On successive visits, some family members hiked to the bottom of the site, and in retrospect, one wonders, "hiking to the bottom of Meteor Crater in a dress?" It was, after all, the 1950s. (Courtesy of Anita Davis Henling and Linley Schrader Brown.)

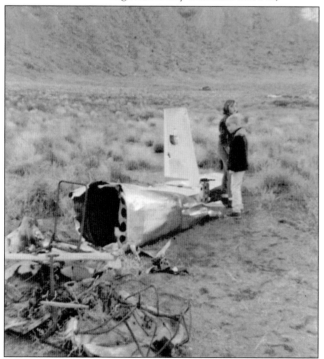

The author's sister Anita Davis and cousin Robert Schrader (foreground) visit the remains of a plane crash in the bottom of the crater in 1966. The plane crashed in August 1964. According to the National Transportation Safety Board, after refueling at Winslow, the pilot attempted to overfly the crater, and when crossing the rim, he could not maintain level flight. An attempt to build up speed by circling in the crater to climb over the rim was unsuccessful, and the aircraft stalled. Both occupants were severely injured but survived. (Courtesy of Anita Davis Henling and Linley Schrader Brown.)

This 1957 photograph was taken with a view looking northward to the Meteor Crater rim as seen from the crater floor. The Meteor Crater Museum can be made out in the center of the photograph on top of the rim. (Courtesy of Anita Davis Henling and Linley Schrader Brown.)

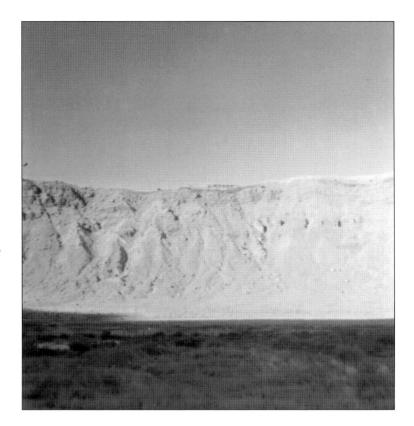

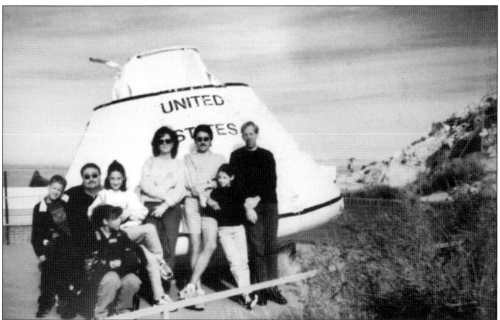

The Lugo family from neighboring Winslow poses in front of the Apollo Test Capsule while visiting the crater in 1998. The family, like many from Winslow, often visits the crater, bringing out-of-town family and guests to the site. (Courtesy of the Stephanie Lugo family collection.)

Each spring, Julia Caffey, a third-grade teacher at Jefferson School in Winslow, would take her class on a field trip to Meteor Crater. These images and those that follow are from the 1984–1985 school year. Above, as the bus pulls away from the school headed for Meteor Crater, Caffey (left in sunglasses) double-checks her paperwork and every student to make sure his or her trip buddy is on board. The feeling of excitement was electric among the class. Below, is it possible that someday some of these students will work or live in space? One of them could be on the first manned expedition to Mars. (Both, courtesy of the Julia Caffey collection.)

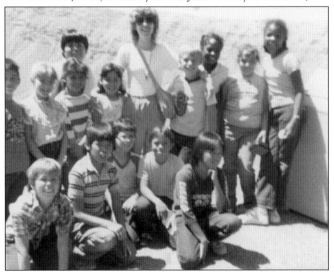

Above, the teacher takes a minute to enjoy the view and a little quiet time. Julia Caffey said it was nice to just stand back and watch the student reactions to the site. They were so excited and happy to finally be at the crater. The class had completed classroom activities, science projects, and journal writing about the solar system. Now, it all came together with "the best field trip ever." Below, a couple of classmates peer into the Apollo test capsule. Caffey related that the students were always amazed that three grown men could fit in such a small spaceship, even more so when she told them the capsule also held equipment the astronauts needed. (Both, courtesy of the Julia Caffey collection.)

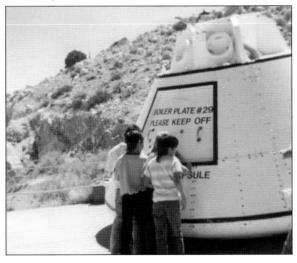

Coraleen Mead and Phyllis Jensen were both third-grade teachers at Bonnie Brennan Elementary School in Winslow for a number of years, and each school year, they would take their students on a field trip to Meteor Crater. These photographs and those following present a visual story of their day at Meteor Crater. Of course, all the students were eager to pose at the lookouts and on the crater rim. All the photographs in this collection are from the 1993–1994 third-grade classes. (Both, courtesy of the Coraleen Mead collection.)

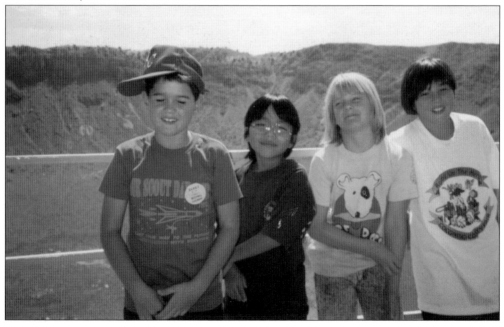

At right, two of the third-grade students pose in front of the astronaut suit display and may be thinking that one day they could become astronauts. Below, a single classmate appears to be in deep thought while studying Meteor Crater and may be wondering what is would be like to hike to the bottom of the site and perhaps discover some meteorites. (Both, courtesy of the Coraleen Mead collection.)

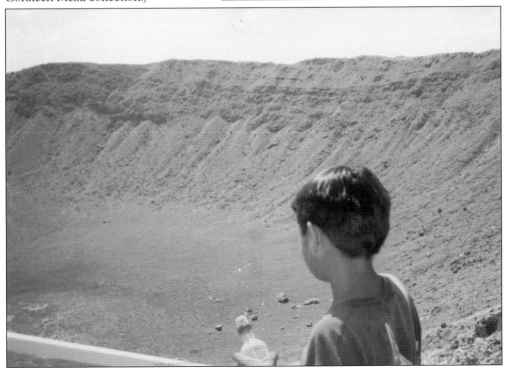

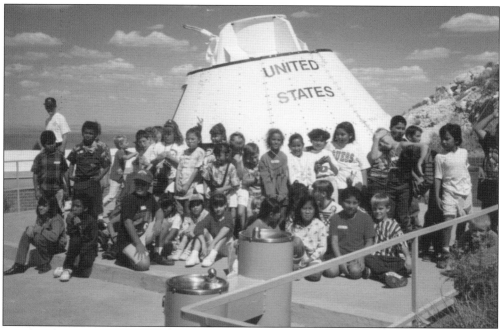

Above, the classes line up for a group photograph in front of the Apollo test capsule. Are there any future astronauts in the group? Below, back to reality and in the classroom, they write about their experiences and impressions of the Meteor Crater visit and look forward to a real treat. As part of the field trip, Coraleen Mead and Phyllis Jensen made a special crater cake for the class. When the cake was ready to serve, each slice would have a crater. (Both, courtesy of the Coraleen Mead collection.)

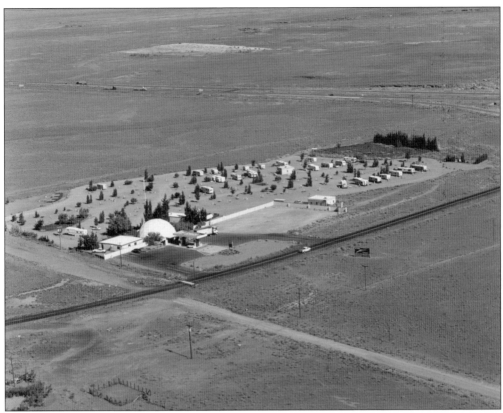

Shown above is an early aerial view of the Meteor Crater RV Park. According to the 2001 *Arizona Guide*, the facility boasts 72 landscaped pull-through spaces, full hook-ups, private restrooms, showers, a recreation room, a playground, and a laundry, as well as the country store. The park is located at the junction of Interstate 40 and Meter Crater Road. Many visitors stay for an extended time, using the park as a base for traveling to other sites in the area. The view in the photograph below looks south on Meteor Crater Road toward the crater rim, at left center on the horizon. (Above, courtesy of Meteor Crater Enterprises, Inc., collection; below, author's collection.)

Two views of the Meteor Crater RV Park look west toward the San Francisco Peaks and Flagstaff. The image above was taken in the mid- to late 1990s. Below is a similar view taken in the winter of 2015. Behind the mature trees, the San Francisco Peaks can be seen capped with snow. (Above, courtesy of Meteor Crater Enterprises, Inc., collection; below, author's collection.)

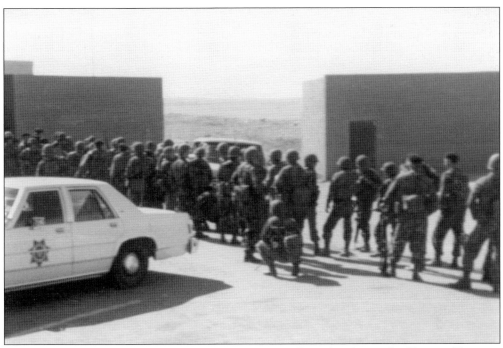

These are two photographs taken by a Meteor Crater staff member during the filming of *Starman* at the site. The movie stars Jeff Bridges and Karen Allen and is about an alien who takes the form of a young widow's husband and asks her to drive him from Wisconsin to Meteor Crater, while the government tries to stop them. In these photographs, the US Army is trying to catch Bridges before he is taken back home by his mother ship. In the 1970s and early 1980s, the Meteor Crater site was featured in three full-length movies: *Damnation Alley* (1974), *Meteor* (1979), and, of course, *Starman* (1984). Television documentaries have also been filmed at the site, and one of the better-known TV shows in the early 1960s, *Route 66*, also visited Meteor Crater. (Both, courtesy of Meteor Crater Enterprises, Inc., collection.)

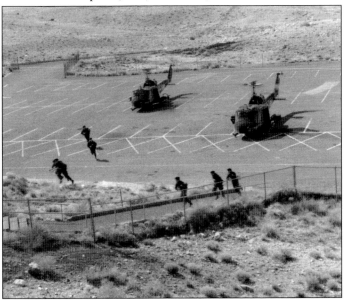

Shown here around 1984 is Gene Collier (left), Meteor Crater site manager, with a special visitor, *Starman* supporting actor Charles Martin Smith, in the gift shop. Smith plays the SETI (Search for Extraterrestrial Intelligence) scientist in the film and chases the extraterrestrial visitor (Jeff Bridges) and his partner (Karen Allen) across the United States as they try to reach Meteor Crater for the alien's rendezvous with a spaceship that would return him home. (Courtesy of Gene and Betty Collier collection.)

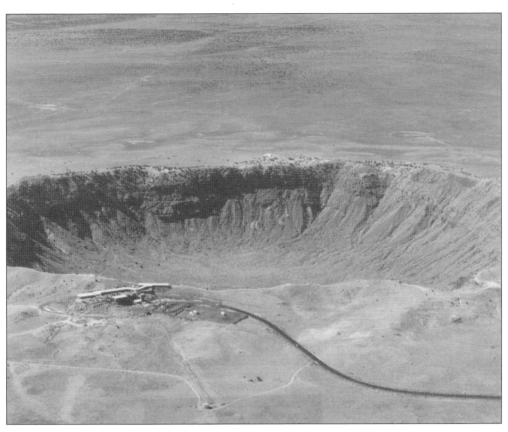

Hiking the Meteor Crater rim and to the bottom of the site was permitted up until the 1970s. Both of the trails were closed to the public due to a number of issues, including injuries and visitors not returning to the crater rim before dark, but the primary reason was to preserve the site for future research. (Both, courtesy of Meteor Crater Enterprises, Inc., collection.)

IT IS TOO LATE

TO BEGIN HIKING THE

3 1/2 MILE RIM TRAIL

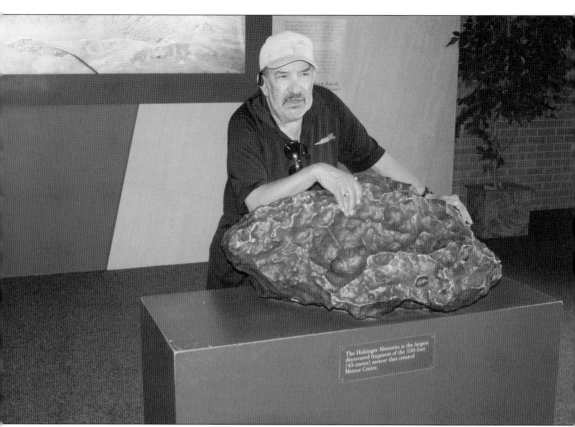

The head tour guide, Eduardo Rubio, stands at the Holsinger Meteorite, welcoming a group of visitors in preparation for the rim tour. Eduardo has been employed at the site for 19 years, and his duties include the daily tours and training new tour guides. There are presently five full-time tour guides sharing the daily schedules. The closest services to the Meteor Crater are located in Winslow, 18 miles to the east on Interstate 40. There is a full-service RV park and general store at the site as well. Some of the employees actually live on-site in one of the company apartments or at the RV park. (Author's collection.)

Eduardo Rubio and group of visitors in the winter of 2005 pay a visit to the original museum site. Notice the large boulder on the ridge, which was most likely uplifted on impact and ejected to where it now rests on the northwest rim. (Courtesy of the Eduardo Rubio collection.)

Tour guide Richard Andrews is pictured in 1997 with a group of students on a field trip to the crater. Richard found some creative ways to entertain students in addition to presenting the Meteor Crater history. For example, he would take a magnet on the tours and let the students check the area to see if they could possibly find a meteorite fragment. (Courtesy of Meteor Crater Enterprises, Inc., collection.)

Shown here is a surprise visitor checking out the visitor walkway on the north crater rim around the 1990s. This is, in fact, Brad Andes, president of Meteor Crater Enterprises, Inc., enjoying the snow-covered scene. (Courtesy of Meteor Crater Enterprises, Inc., collection.)

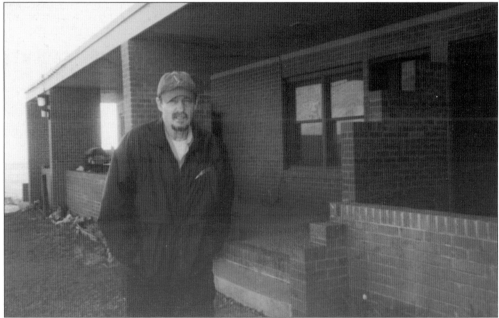

Steve Butterfield, seen here in 2005, has been working at the site for over 23 years. Like all the employees, he has rotated positions during his employment. Steve commented that while he enjoys the environment, it is not for everyone. A person should enjoy the outdoors, quiet, solitude, and the remoteness of the lifestyle at the crater. Steve, like the other employees, appreciates the work schedule of four days on and three days off, allowing the time to travel to Winslow or Flagstaff for personal business and shopping. Special thanks go to Steve Butterfield. (Courtesy of the Eduardo Rubio collection.)

Shown here is a couple from Ireland at the Moon Mountain Telescope lookout. The couple was in the United States specifically to tour across Route 66, starting in Chicago and traveling to the terminus at the Pacific Ocean on the Santa Monica Pier in Southern California. Notice the Route 66 shirts worn by the two. They were on one of several Route 66 Tour packages that include the self-drive following the legendary "Mother Road," the ultimate road trip through America's heartland, with a visit to Meteor Crater. (Author's collection.)

Chantal de Vos and Tim van der Waart (left) visit Meteor Crater as part of a western park tour. The following is an excerpt from their letter written to the author: "It was interesting to note the landscape as we approached the Meteor Crater changed somewhat to a moon-like landscape. Upon arrival, we joined a tour of approximately 30 minutes. When we first viewed the crater from the rim, we actually couldn't believe that a meteorite could cause such a big hole. It's really impressive to see. Even when standing on the rim of the crater it's difficult to estimate the size of the meteorite. Subsequent to the rim tour we visited the museum which gave us some additional information about the site as well as information about impact craters in general. It was interesting to experience the crater impact simulation that determined the size of the meteorite, the density, velocity and angle of impact." Also pictured are Bob, Perla, and son Sammy Apodaca (right) from Phoenix, and senior tour guide Eduardo Rubio (front). (Author's collection.)

The author is shown here (center) on one of the guided tours, flanked by two visitors from afar. The couple, from New Delhi, India, were visiting the United States and touring throughout the Southwest, including the visit to the Meteor Crater. (Photograph by Eduardo Rubio, author's collection.)

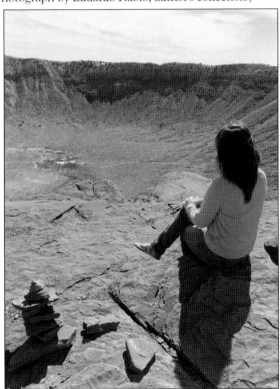

Winslow native and Arizona State University student Megan Lymer is shown in a moment of solitude on the crater rim. The following are her thoughts about the site. "Growing up in Winslow you always knew about 'The Crater.' I first experienced the crater when on my fifth grade field trip. Even after visiting multiple times, then going off to school, the crater never loses its power to make you realize what a huge universe you are living in. It symbolizes home to me." Lymer is the daughter of the author's niece. (Courtesy of Megan Lymer.)

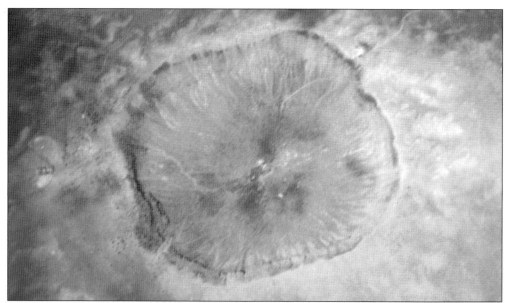

This is the first aerial photograph of Barringer Meteorite Crater, also known as Meteor Crater. It was taken by Charles Lindbergh in July 1929 during a survey by Lindbergh to identify potential airport refueling sites for the country's first commercial transcontinental airline flights. Lindbergh proposed a site in Winslow, 18 miles to the east, and an airport was developed there. It continues to be used today by general aviation and aerial tankers used to fight forest fires. The airport is named for Lindbergh. (Courtesy of Meteor Crater Enterprises, Inc., collection.)

Flying at 21,000 feet over Meteor Crater in this image, an F-35 aircraft, designated AA-1, is on its ferry flight from Lockheed Martin in Fort Worth, Texas, to the F-35 Integrated Test Force at Edwards Air Force Base, California, in October 2008. The visitor center and parking lot can be seen directly below the nose of the aircraft. AA-1 was the first F-35 built by Lockheed Martin. Special thanks go to lifelong friend Byron Allen. (Courtesy of Lockheed Martin.)

Experience The *BEST* Preserved Meteorite Impact Site on Earth!

Meteor Crater

Exit 233 • 18 mi. • MeteorCrater.com

This is one of the few remaining signs along Interstate 40. It is located on westbound Interstate 40 when drivers are leaving Winslow. Exit 233 to the crater site is about 15 minutes past this sign. Up until the Highway Beautification Act, there were a number of Meteor Crater billboard signs along Route 66 and subsequently Interstate 40. The cornerstone of the beautification initiative, the Highway Beautification Act of 1965 called for control of outdoor advertising, including removal of certain types of signs, along the nation's growing interstate system and the existing federal-aid primary system. (Author's collection.)

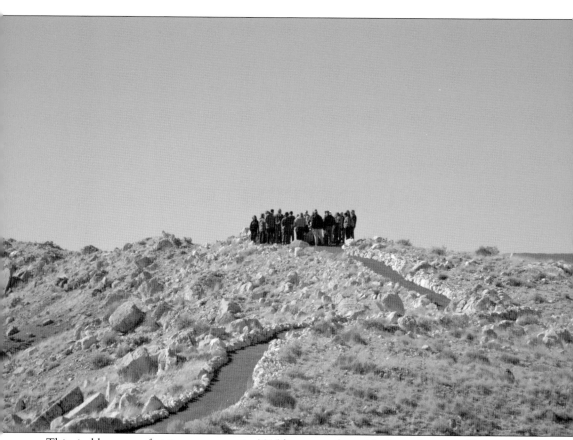

This sizable group of visitors on a tour in 2015 listens to the guide share the storied history about the meteorite impact and the ultimate discovery and scientific study of the site. The photograph has a view looking westward on the Meteor Crater rim trail just outside the visitor center. (Author's collection.)

Seven

MUSEUMS OF YESTERDAY, TODAY, AND TOMORROW

The original Meteor Crater Museum was built in 1912 and used as housing. Not officially opened as a museum until 1942, it was a one-room stone building constructed on the northwest rim of the crater. It could hardly be termed a museum, but it was a start. The site offered only a few meteorite displays and next to nothing about the site history or significance of the one-mile-wide impact crater. Getting to the site was an adventure in itself. There was a crude dusty and bumpy two-lane road heading south from Route 66 six miles to the museum site. It would be over 40 years before the current building was constructed around 1959 and then rebuilt around 1961 after the roof blew off. There is a bit of humor tied to that incident. It seems that when the roof went flying, the wind took hundreds of Meteor Crater postcards and spread them across the northern plateau—not exactly the way they planned to get the word out. The gift shop building and old apartments were built around 1963. The gift shop was expanded in 1986, at the same time the newer apartments were built. The theater was built in 1999. The old ticket building was constructed in 1995 and the new one completed in 2013. Today, the visitor center offers 24 engaging and informative exhibits, making it one of the most extensive museums of its type. It was 50,000 years ago when a giant meteor, weighing several hundred thousand tons, traveled through space and impacted Earth. Visitors to the center can relive the intensity of this impact. The wide range of exhibits fascinate and educate everyone on the aspects of meteors and their encounters with Earth. Daily tours are available on the half hour throughout the day, weather dependent. Meteor Crater Enterprises, Inc., recently completed a master planning process that will guide it through an estimated $20 million in improvements, creating a state-of-the-art facility. The planned expansions will improve energy and operational efficiency and are intended to add to the visitor's education and enjoyment.

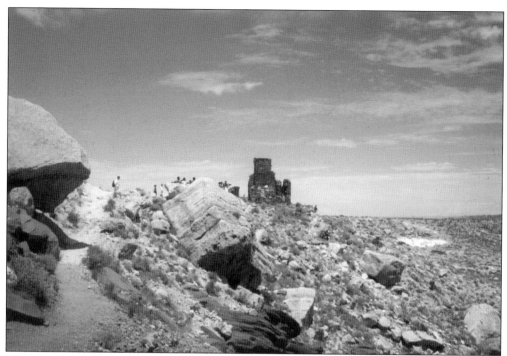

This view from the western rim trail looking north shows a tour group gathering at the original museum building remains. The visible trail at left is accessible to the public as part of the rim tour in non-summer months. (Courtesy of Meteor Crater Enterprises, Inc., collection.)

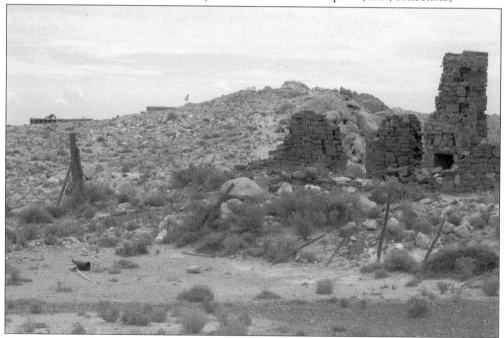

The remains of the fireplace and partial walls are all that is left of the original museum. This is a view looking east along the north rim trail in 2015. The buildings just over the ridge are the present-day visitor center. (Author's collection.)

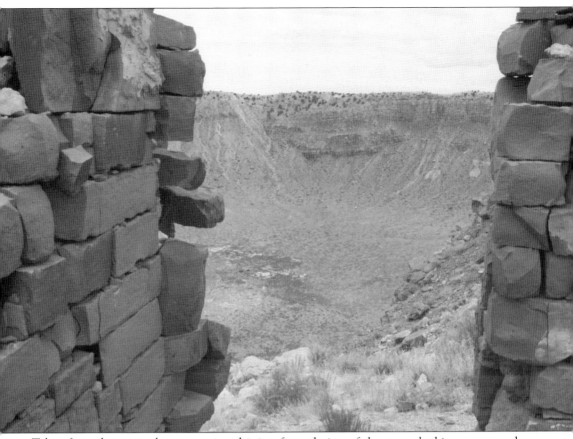

Taken from the original museum site, this is a framed view of the crater looking across to the southern rim, directly into the center of the floor. Just a few steps from the building's remains is the crater's edge. Guided tours during the winter months take visitors to Meteor Crater out to this site. (Author's collection.)

This root cellar was built adjacent to the original museum building. The structure is located just a few yards west of the old museum remains. It was built underground and used for food storage. Root cellars were used for keeping food supplies at a low temperature and steady humidity, protecting them from freezing during the winter and heat during the summer to prevent spoilage. (Author's collection.)

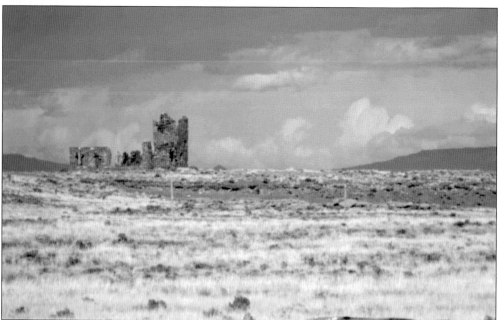

This is the remains of the Ninninger Museum, located just east of the present-day road to Meteor Crater. The museum remains are just a few yards north of old Route 66. It was constructed sometime in the 1930s and taken over by Dr. Harvey Ninninger in 1946 to house the American Meteorite Museum. From October 1946 to September 1953, the building served not only as the museum but as his home, workplace, and lab. The Ninninger Meteorite Museum was never associated with Meteor Crater. (Author's collection.)

Above, visitors line up for entrance into the former museum building. This building was originally constructed around 1959 and rebuilt around 1961 after the roof blew off in a powerful windstorm. The image below shows the same building viewed looking to the west along the crater rim. (Both, courtesy of Meteor Crater Enterprises, Inc., collection.)

This vintage photograph was taken from the then visitor parking lot with a view looking southwest toward the museum building on the crater's north rim. The museum entrance is located in the center of the building. (Courtesy of Meteor Crater Enterprises, Inc., collection.)

The view in the above photograph looks east from the museum building. The structure to the left is the original Meteor Crater employees' apartment building. Below, a different view from the rim trail looks north to the parking lot and employees' apartment building. (Both, courtesy of Meteor Crater Enterprises, Inc., collection.)

George Foster is pictured here at the Meteor Crater Museum. George and his wife, Ivy, first arrived at the site in 1947, but it was not until 1954 that he was hired as the manager. He held this position until his retirement in 1967. The Fosters remained loyal during their tenure, often working 13-hour days seven days a week. While living and working at the site, George wrote and published three books about Meteor Crater including: *The Barringer (Arizona) Meteorite Crater* (1957), *The Meteor Crater Story* (1964), and *The Meteor Crater Story Fourth Edition* (1978). (Courtesy of Meteor Crater Enterprises, Inc., collection.)

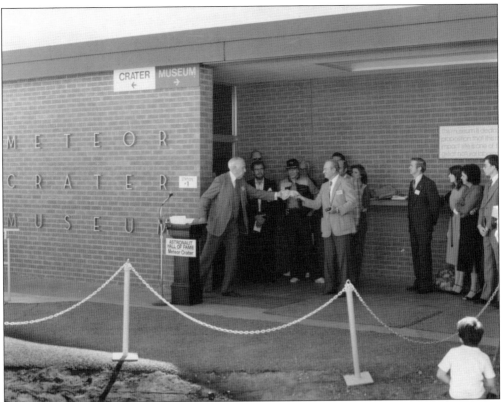

This is the Astronaut Hall of Fame dedication, held on October 12, 1979. Gary Shoemaker was host and master of ceremonies. Other attendees at the event included astronaut Ron Evans, shown below in a check jacket at the speaker's podium. Ron Evans's first and only spaceflight was as command module pilot of Apollo 17, the last US manned mission to the moon in December 1972. (Both, courtesy of Meteor Crater Enterprises, Inc., collection.)

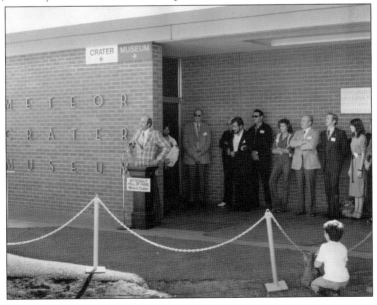

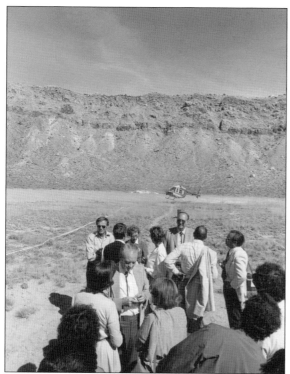

At left, invited guests of the Astronaut Hall of Fame dedication ceremonies continue the activities on the floor of Meteor Crater. The guests were flown to the bottom by the helicopter shown in the background. Below, an unidentified speaker addresses the dignitaries, invited guests, and visitors during the dedication ceremonies at the museum. Among the group at the presentation below are Warwick J. Hayes, then chairman of the board, Meteor Crater Enterprises, Inc.; George G. Shoemaker, general manager and president, Meteor Crater Enterprises, Inc.; and Ernest Chilson, past president, Meteor Crater Enterprises, Inc. (Both, courtesy of Meteor Crater Enterprises, Inc., collection.)

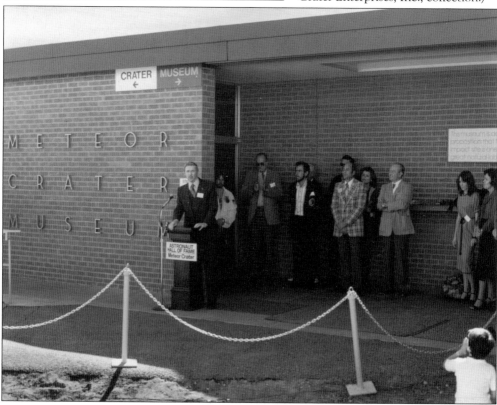

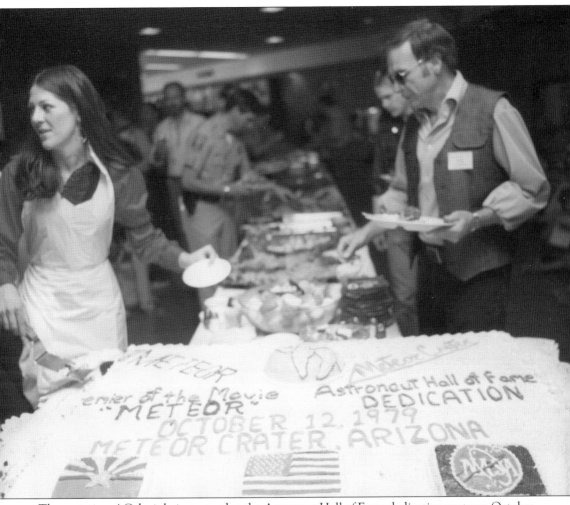

The party is on! Cake is being served at the Astronaut Hall of Fame dedication party on October 12, 1979, at the Meteor Crater Museum. The gathering included dignitaries from NASA in addition to the site visitors. (Courtesy of Meteor Crater Enterprises, Inc., collection.)

These two photographs show the construction and expansion of the museum entrance and the ticket building addition during the mid-1990s. Ground breaking on the additions and museum expansion started in 1994, and the work took only one year, being completed in 1995. (Both, courtesy of Meteor Crater Enterprises, Inc., collection.)

The illustration at right is a top-down layout view of the visitor center. Once visitors purchase their entry tickets, the stairs or elevator will take them up to the open-air Astronaut Park, which includes the Astronaut Wall of Fame and Apollo test capsule. The present-day facilities include a restaurant, gift shop, rock shop, historical displays, and meteorite displays. Moving to the top floor, visitors find the theater and the outside exit to the self-guided rim tour and viewing platforms. Guided tours are available daily throughout the year. Below, to the lower left, is the present-day museum entry. Employee apartments can be seen to the upper left. (Right, courtesy of Meteor Crater Enterprises, Inc., collection; below, author's collection.)

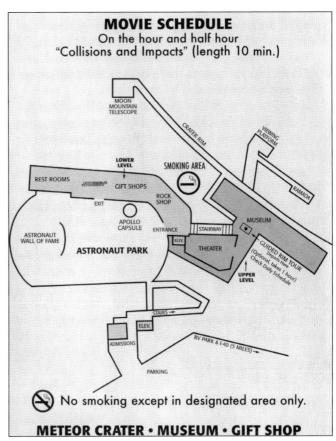

MOVIE SCHEDULE
On the hour and half hour
"Collisions and Impacts" (length 10 min.)

MOON MOUNTAIN TELESCOPE

CRATER RIM

VIEWING PLATFORM

LOWER LEVEL

SMOKING AREA

REST ROOMS SUBWAY GIFT SHOPS

RAMADA

EXIT

ROCK SHOP

MUSEUM

APOLLO CAPSULE ENTRANCE STAIRWAY

ASTRONAUT WALL OF FAME

ELEV.

THEATER

GUIDED RIM TOUR
(Optional takes 1 hour)
Check Daily Schedule

ASTRONAUT PARK

UPPER LEVEL

STAIRS

ELEV.

ADMISSIONS

RV PARK & I-40 (5 MILES)

PARKING

🚭 No smoking except in designated area only.

METEOR CRATER • MUSEUM • GIFT SHOP

115

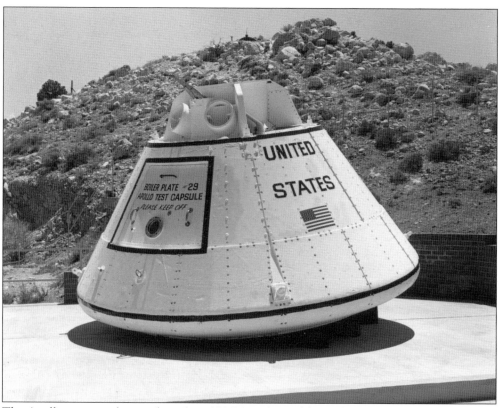

The Apollo test capsule is on loan from NASA and was delivered to Meteor Crater in 1978. In the photograph above, it was originally located on the north rim of the crater, adjacent to the museum. It remained there for 22 years until the Astronaut Park was completed in 1999. Below, the moving crew places the capsule into position at its current home in Astronaut Park, just outside the visitor center. (Both, courtesy of Meteor Crater Enterprises, Inc., collection.)

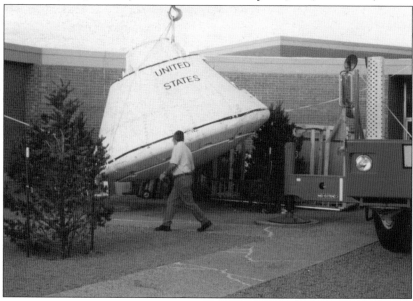

Above is the Astronaut Wall of Fame that was constructed in the mid-1990s. It contains plaques with the names of all the astronauts who achieved spaceflight along with their mission numbers. This includes every American astronaut who has flown in space from the Mercury program—starting in May 1961, when Alan Shepard made his suborbital flight, becoming the first American in space—through the Gemini, Apollo, and Space Shuttle programs, and most recently International Space Station (ISS) voyagers. Below asks the question, will Mars be the next destination? (Both, author's collection.)

Turning our eyes towards the future of space exploration, Mars is our next destination.

This is the ribbon-cutting ceremony for the opening of the Discovery Center Theater in 1999. Shown from left to right above are Brad Andes, president, Meteor Crater Enterprises, Inc.; H. Alan Tremaine, board director; George Shoemaker, general manager; and Robyn Messerschmidt. Below is Chris Bavasi, left, then mayor of Flagstaff. Bavasi served as the mayor of Flagstaff from 1988 to 2000. The person on the right is unidentified. (Both, courtesy of Meteor Crater Enterprises, Inc., collection.)

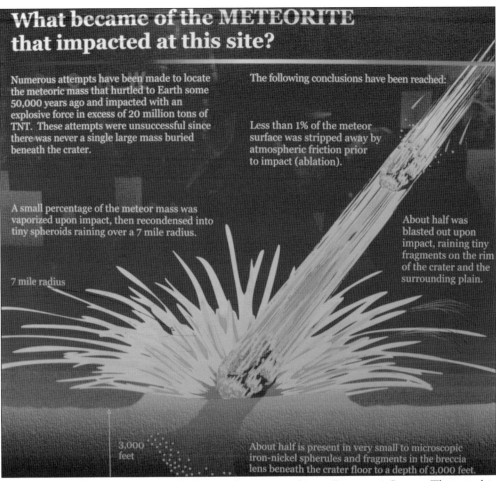

What became of the METEORITE that impacted at this site?

Numerous attempts have been made to locate the meteoric mass that hurtled to Earth some 50,000 years ago and impacted with an explosive force in excess of 20 million tons of TNT. These attempts were unsuccessful since there was never a single large mass buried beneath the crater.

The following conclusions have been reached:

Less than 1% of the meteor surface was stripped away by atmospheric friction prior to impact (ablation).

A small percentage of the meteor mass was vaporized upon impact, then recondensed into tiny spheroids raining over a 7 mile radius.

About half was blasted out upon impact, raining tiny fragments on the rim of the crater and the surrounding plain.

7 mile radius

3,000 feet

About half is present in very small to microscopic iron-nickel spherules and fragments in the breccia lens beneath the crater floor to a depth of 3,000 feet.

Shown here is one of the many displays in the Meteor Crater Discovery Center. This graphic presents an excellent explanation and visual of the meteorite impact. It helps explain the earlier mystery of why there have not been more large meteorite rocks and fragments found in and around the crater site. (Author's collection.)

This is Lanah Butterfield, vice president of operations for Meteor Crater, delivering some blacktop for paving the trail from the visitor center out to the original museum building remains, shown in the upper left. All members of the Meteor Crater staff, from the top down, are expected to perform a variety of jobs in maintaining the visitor center and grounds. (Courtesy of Meteor Crater Enterprises, Inc., collection.)

Here are two different views from the trail rim. The image above is looking west across the rim at the remains of the original museum building on the far right. Below, the view is looking 180 degrees (to the east) along the same trail at the present-day visitor center. Visitors are gathering at the upper viewing platform in the right center of the photograph. (Both, author's collection.)

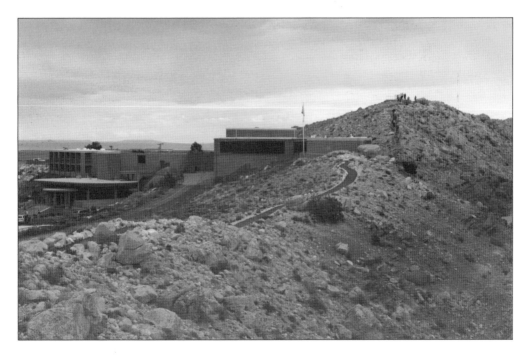

Shown are two different views of the present-day visitor center. The view above is looking southwest from the Bar T Bar Ranch road. Below, the older museum building is in the center of the photograph. Built in the 1950s, it is now a part of the modern-day visitor center. The image was taken from the trail leading up to the Moon Mountain Telescope lookout. (Both, author's collection.)

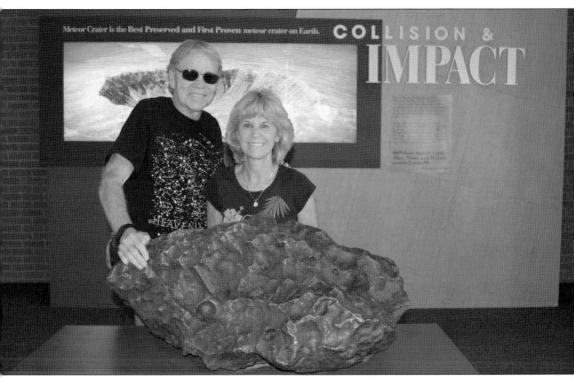

The author (left) and his wife, Cindy, are shown with the Holsinger Meteorite display in the Meteor Crater Discovery Center. The image was taken following the couple's hike around the approximately two-and-one-half-mile Meteor Crater rim for a closer look at the crater and some photo opportunities. (Photograph by Jeff Beal, Meteor Crater staff, author's collection.)

Here is a photograph taken from the south rim with a different perspective of the visitor center. The image, taken with a telephoto lens, clearly shows the lower ramada overlook (directly below the visitor center), and to the right is the lower viewing platform. In the far upper right is the

Moon Mountain Telescope viewing point. Some visitors can be seen on the pathway along with a couple standing at Moon Mountain Lookout. (Author's collection.)

This is the Meteor Crater Visitor Center seen during the author's hike around the crater rim. The photograph was taken from the northeastern trail, no longer accessible to the public. The San Francisco Peaks rise from the high desert about 40 miles west of the crater. (Author's collection.)

These are an architect's rendering of planned improvements to the Meteor Crater Visitor Center. The above image is the expanded visitor center exterior, and below is the interior of the visitor center, including an open area to relax, have a bite to eat, recharge, and continue the tour. These improvements are part of a 10-year expansion plan. Special thanks go to Mittelstaedt, Cooper & Associates Limited. (Both, courtesy of Meteor Crater Enterprises, Inc., collection.)

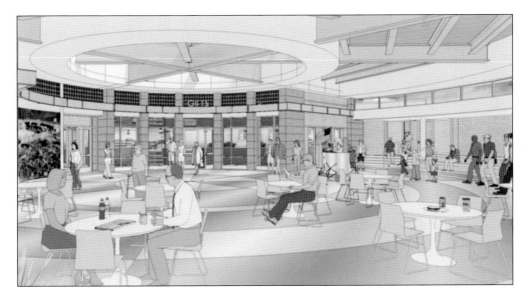

DISCOVER THOUSANDS OF LOCAL HISTORY BOOKS
FEATURING MILLIONS OF VINTAGE IMAGES

Arcadia Publishing, the leading local history publisher in the United States, is committed to making history accessible and meaningful through publishing books that celebrate and preserve the heritage of America's people and places.

Find more books like this at
www.arcadiapublishing.com

Search for your hometown history, your old stomping grounds, and even your favorite sports team.